THE GOSPEL IN ART BY
THE PEASANTS OF SOLENTINAME

THE GOSPEL IN ART BY
THE PEASANTS OF SOLENTINAME

Edited by Philip and Sally Scharper

ORBIS BOOKS
Maryknoll, New York

GILL AND MACMILLAN
Dublin

First published as *Die Bauern von Solentiname malen das Evangelium, Mit Meditationen von Helmut Frenz,* copyright © 1982 Burckhardthaus-Laetare Verlag GmbH, Gelnhausen/Berlin, in collaboration with Jugenddienst-Verlag, Wuppertal

English language text copyright © 1984 Orbis Books, Maryknoll, NY 10545

First published in the United States and Canada by Orbis Books, Maryknoll, NY 10545
First published in Ireland by Gill and Macmillan, Goldenbridge, Dublin 8

Printed in Spain

Orbis ISBN 0-88344-382-1
Gill and Macmillan ISBN 0-7171-1333-7

Introduction

The text facing each painting has been excerpted from the four-volume *The Gospel in Solentiname,* the collected commentaries of the peasants on the Gospel passage read at Mass each Sunday. No other time or place offers us such a detailed and comprehensive record of what "ordinary" Christians made of the Gospel in the context of their own lives.

Commentaries on the Gospel abound from the age of the Fathers to our own. But in these commentaries, whether scholarly or "popular," the laity were being told what the Gospel *should* mean to them. Between Jesus and "the crowds who flocked to hear him" stood always a professional interpreter, as though Jesus, the Word of God, spoke a language different from that of his hearers.

The Gospel in Solentiname is a dramatic, and to some a shocking, rejection of these patterns of the past. They set forth not what the Gospel should mean, but what the words and works of Jesus actually *did* mean to them in their daily lives.

The wide reception of *The Gospel in Solentiname* has not been, as one might suppose, based on a wide circulation in different countries among the counterparts of the peasants of Solentiname. Theirs has not been an "underground Bible." On page 69 may be found excerpts from reviews of the English translation. In each instance the judgments made are those of either distinguished scholars or "pastoral agents" who, in a reversal of roles, are learning from the class of people they are accustomed to teaching.

In style, the paintings in this book will remind many of the paintings in the catacombs. The art of the catacombs and that of Solentiname are also alike in this: they both preach the good news that Christ has made us free, and that faith in him births, even in persecution, a paradoxical joy and hope, whether the persecutor be Nero or Somoza.

There is yet another link between the catacombs and Solentiname: in neither place did the artists have a patron, as Christian artists have had from the time of Constantine to our own.

It must be noted, however, that the patron had sufficient wealth (and power) to employ the artist to serve the patron's cause, and hence could dictate to the artist the subject for his brush or chisel and even, in some cases, prescribe how the brush or chisel should be handled. The artists of Solentiname have no patron.

Christian artists, under a patron or not, attempt to make the persons and incidents of the Gospel come alive for the people of their own time. The artists keep in mind their own, not future, generations.

Thus, Christ in Byzantine art sits enthroned as both Emperor and Judge, who dominates rather than loves his people. In much of the Italian Renaissance Christ is a comely prince, Mary a noble lady of beauty and courtly grace. In the art of Solentiname both Christ and Mary are peasants, seen not in the artists' imaginative reconstruction of what Bethlehem, Nazareth, or Calvary might have looked like, but seen in the familiar settings of Solentiname, with its thatch-roofed buildings, bright blue waters, and lush vegetation starred by brilliant flowers.

The peasants' comments on the Gospel—simple, direct, often earthy—show forth their deep conviction that Jesus lives and is, indeed, present among them. So, too, the paintings reflect the peasants' faith that the Gospel is the living word of the living God heard in their world. Gabriel finds Mary at her sewing machine. Bottles of Coca-Cola stand, symbolically, on Herod's table. The troops of Herod/Somoza carry automatic weapons and wear uniforms supplied by the United States. And the reader will notice in the Resurrection scene that the crude wooden crosses bear the names of Elvis, Felipe, and Donald, young men frequently quoted in the text.

The commentaries were gathered and published before Somoza's destruction of Solentiname in 1977 and the overthrow of Somoza in 1979. The paintings were done in 1981 and 1982, when the peasants had returned to Solentiname to begin its reconstruction.

The names of the painters are given on the bottom of each page of text.

The Annunciation

Luke 1:26-36

ERNESTO said: " 'Jesus' was a name that was usually translated as 'Savior' or 'Salvation,' but now it is better translated as 'Liberator' or 'Liberation.' The Hebrew name is *Jeshua,* which means 'Yahweh is liberation.' "

FELIPE: "That angel was being subversive just by announcing that. It's as though someone here in Somoza's Nicaragua were announcing a liberator."

ELVIS: "And Mary joins the ranks of subversives, too, just by receiving that message. Even the name 'Jesus' was a dangerous name. . . ."

The angel said to her,
"The Holy Spirit will come over you,
and the power of God the Highest
will wrap you like a cloud."

ERNESTO: "We already know that the Holy Spirit is the same as saying the 'spirit of God'—in the sense of 'God's way of being' or God's character—and it's also the same as saying 'Love.' And the church has called this Holy Spirit 'Father of the poor.' "

Young JULIO: "So it's the spirit of justice because it's Love. The spirit of social justice, the spirit of change, revolution. Jesus was born from this spirit."

NATALIE, who had been the midwife at the births of almost all these young people: "Jesus is the son of Mary and of Love."

OLIVIA, the mother of Gloria and Alejandro: "Then Mary married Love, or the Spirit of Love."

ERNESTO: "And each of us is destined to marry this same love."

Then Mary said,
"I am the slave of the Lord;
let God do with me as you have told me."
And with this the Angel went away.

Old TOMAS, Felipe's father: "That shows she's very humble. She feels like a poor, humble little thing, instead of feeling proud because of what they told her."

ALEJANDRO, Olivia's son: "It seems to me that here we should admire above all her obedience. And so we should be ready to obey too. This obedience is revolutionary, because it's obedience to love. Obedience to love is very revolutionary, because it commands us to disobey everything else."

Miriam Guevara

You shall conceive and bear a son,
and you shall give him the name Jesus.
Luke 1:31

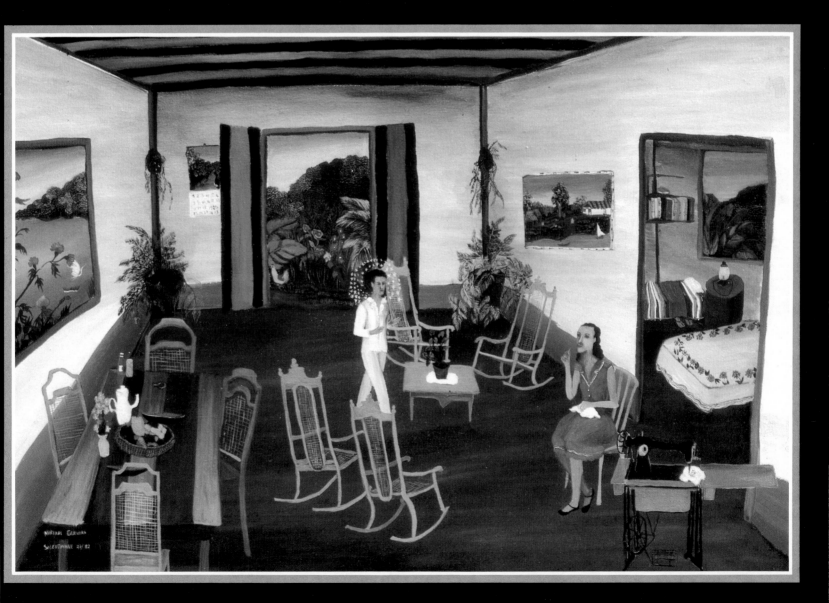

The Visitation

Luke 1:39–56

ERNESTO: "The pregnant Mary had gone to visit her cousin Elizabeth, who also was pregnant. Elizabeth congratulated her because she would be the mother of the Messiah, and Mary broke out singing":

> *My soul praises the Lord,*
> *my heart rejoices in God my Savior.*

ERNESTO: "The Song of Mary, the *Magnificat,* is traditionally known by that name because it is the first word in the Latin."

ESPERANZA: "She praises God because the Messiah is going to be born, and that's a great event for the people. She calls God 'Savior' because she knows that the Son that he has given her is going to bring liberation."

ANDREA: "She recognizes liberation. . . . We have to do the same thing. Liberation is from sin, that is, from selfishness, from injustice, from misery, from ignorance—from everything that's oppressive. That liberation is in our wombs too, it seems to me . . ."

> *And from now on all generations*
> *will call me happy.*

OLIVIA: "She says that people will call her happy. . . . She feels happy because she is the mother of Jesus the Liberator, and because she also is a liberator like her son, because she understood her son and did not oppose his mission."

> *He has shown the strength of his arms;*
> *he conquers those with proud hearts.*

Old TOMAS, who can't read but always talks with great wisdom: "They are the rich, because they think they are above us and they look down on us, since they have the money. . . . And a poor person comes to their house and they won't even turn around to look. They don't have anything more than we do, except money. Only money and pride, that's all they have that we don't."

ANGEL: "I don't believe that's true. There are humble rich people and there are proud poor people. If we weren't proud we wouldn't be divided, and we poor people are divided."

GLORIA: "She spoke for the future, it seems to me, because we are just barely beginning to see the liberation she announces."

WILLIAM: "But the people can't be liberated by others. They must liberate themselves. God can show the way to the Promised Land, but the people themselves must begin the journey."

Gloria Guevara

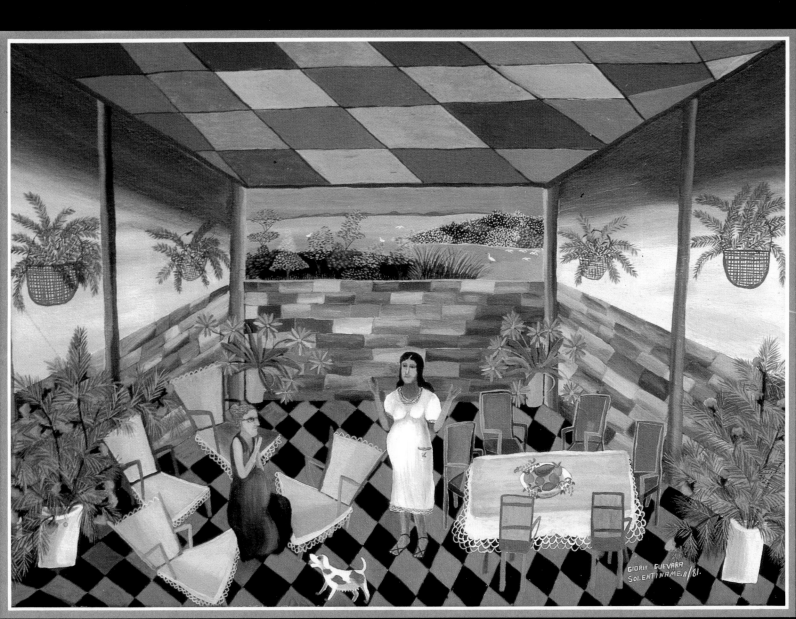

The Nativity

Luke 2:6–7

At midnight we were in the little church in Solentiname celebrating Christmas Mass.

REBECA: "From the moment of his birth, God chose conditions like the poorest person's, didn't he? I don't think God wants great banquets or a lot of money or for business to make profits off the celebration of his birth."

FELIX, a middle-aged *campesino:* "The Scriptures are perfectly clear. The fact is that Christ was born as a poor little child, like the humblest person. The Scriptures keep telling us this, and I don't understand why we don't see it."

JOSE, the carpenter: "The change has to be for everybody. We shouldn't try to dominate each other either. Just now we read that Jesus was born poor, among the animals. He was born there for a reason."

Old TOMAS, who besides being a farmer is a good fisherman: "To teach us not to seek riches, not to have a big house to have a child in, right? Just what's natural."

ERNESTO: "At the Last Supper Christ also spoke of his death as a birth. Every woman suffers great pain when she is going to give birth, but afterwards she is filled with joy when the child is born. This is how he explained his death and also all human tragedy. Women understand these things better. And his mother, Mary, would understand it very well, Mary who had her labor pains in a stable on the first Christmas. Perhaps he said this especially for her since she would suffer so much during his passion. But he said it for all of us, too. Human tragedy has meaning. It is for birth."

Outside there was a lovely moon on both sides of the little church. The lake was calm. Now it was just the young people who went on talking.

"Joseph and Mary were turned away from the inn because they were poor. If they'd been rich they'd have been welcomed in."

"God wanted his son to be born in a pigsty, in a stable. He wanted his son to belong to the poor class. If God had wanted him to be born to a rich lady, that lady would have had a room reserved at that hotel—especially arriving in her condition."

"With today's Gospel, it seems to me that no poor person should feel looked down upon. Christ is with us poor people."

"Jesus was rejected in Bethlehem because he was poor, and he goes on being rejected in the world for that same reason. When you come down to it the poor person is always rejected."

Carlos García

10

She wrapped him in swaddling clothes,
and laid him in a manger.
Luke 2:7

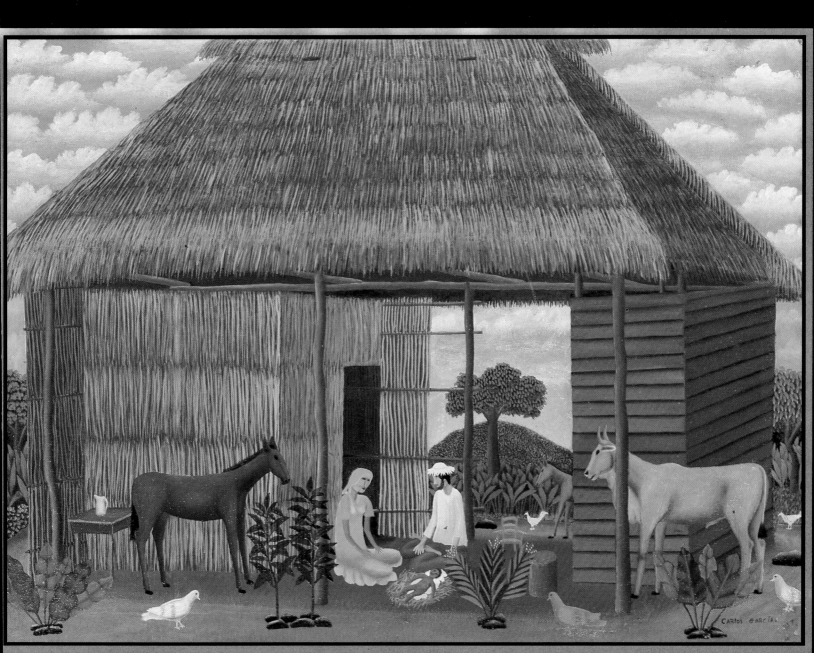

The Shepherds of Bethlehem

Luke 2:8–20

OSCAR: "He was born in a farmyard. He came for the sake of the poor people. He came as the Liberator. That's why he had to be born like that. He had to set an example for us, so nobody would think they are better than others, so we would feel all the same—equal."

ANGEL: "If they'd been offered a good house, wouldn't Mary and Joseph have accepted it?"

RAFAEL: "I bet they wouldn't have turned it down."

OSCAR: "Then it would have been better if he hadn't come."

ANGEL: "The only reason they didn't accept a house is because nobody offered them one."

JULIO: "Why didn't anyone offer them one?"

OSCAR: "They were very poor. That's why."

Old TOMAS: "Maybe people thought that they were slippery characters, that they were going to steal."

FELIX: "That's what happens nowadays. If some raggedy people come to the city and look for a place to stay they don't get any, or if they do it'll be off in a chicken coop, to sleep with the chickens."

Old TOMAS: "If he had been born in a rich man's house the shepherds wouldn't have been able to get there, because it was a fancy house. Maybe they wouldn't even have let the shepherds in."

OSCAR: "The shepherds wouldn't even have wanted to go there because they would have seen he wasn't coming for them but for the rich."

ERNESTO: "And the rich don't need liberation. What liberation do the rich need?"

WILLIAM: "The rich need to be liberated from their money—and when the poor are liberated, then the rich will be liberated too."

FRANCISCO: "And the poor also have the chance to be great, like the Messiah who was born like the common people."

But Mary kept all this in her heart . . .

OSCAR: "Mary knew who her child was. The shepherds knew. The king and the rich people didn't know. The same thing happens now. Not everybody knows about the coming of Jesus."

JULIO: "I think a lot of people know about it, but what happens is that there's a lot of fear. They don't dare approach as the shepherds did because they are afraid."

Mariíta Guevara

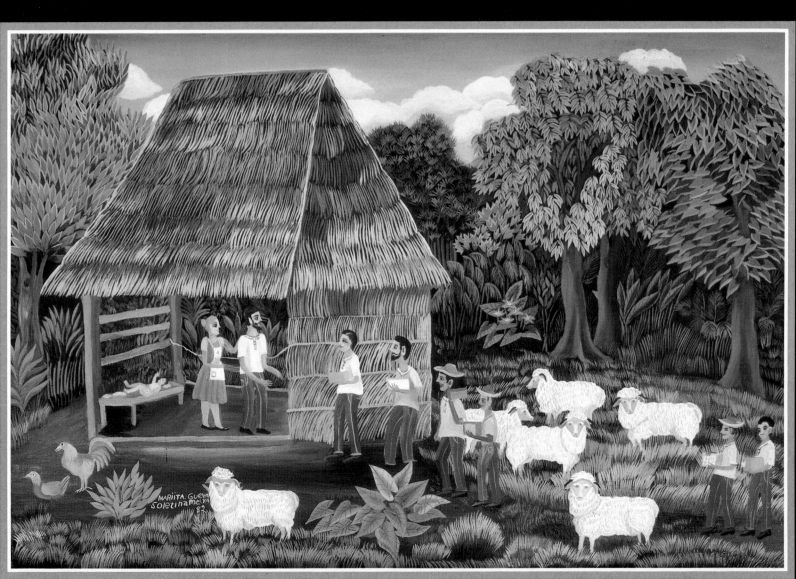

The Wise Men

Matt. 2:1–12

Jesus was born in Bethlehem of Judea
in the days of Herod the King

ERNESTO: "These words of Matthew, 'in the days of Herod the King,' are telling us that Jesus was born under tyranny. There were three Herods, or, as we might say in Nicaragua, 'three Somozas': Herod the elder, Herod his son, and a grandson Herod. Herod the elder, the one at the time of Jesus' birth, had ordered two of his sons to be strangled on suspicion of conspiracy and had also killed one of his wives. At the time of Jesus' birth he killed more than three hundred public servants on other suspicions of conspiracy. So Jesus was born in an atmosphere of repression and terror. It was known that the Messiah was going to be king, and that's why the wise men arrived asking for the King of the Jews, meaning the Messiah."

LAUREANO: "I think these wise men loused things up when they went to Herod asking about a liberator. It would be like someone going to Somoza now to ask him where's the man who's going to liberate Nicaragua."

ADAN: "It seems to me that when those wise men arrived they knew that the Messiah had been born and they thought Herod knew about it and that the Messiah was going to be a member of his family. If he was a king, it was natural that they should go look for him in Herod's palace. But in that palace there was nothing but corruption and evil, and the Messiah couldn't be born there. He had to be born among the people, poor, in a stable. They learned a lesson there when they saw that the Messiah had not been born in a palace or in the home of some rich person, and that's why they had to go on looking for him somewhere else."

FELIPE: "Then the chief priests were summoned by Herod, who had killed a lot of people."

DON JOSE: "The priests knew he was going to be born in a little town, among the common people. But they were in Jerusalem, visiting with the powerful and the rich in their palaces. Just as today there are a lot of church leaders who know that Jesus was born in Bethlehem, and every year they preach about this at Christmas, that Jesus was born poor in a manger, but the places they go to all the time are rich people's houses and palaces."

Old TOMAS: "The wise men came and opened their boxes—some perfumes and a few things of gold. It doesn't seem as if he got big presents. Those foreigners, who could have brought him a big sack of gold, a whole bunch of coins, or maybe bills, they didn't bring him these things. What they brought to him were little things."

MARCELINO: "The stores are full of Christmas presents in the cities, and they make lots of money. But it's not the festival of the birth of the child Jesus. It's more like a festival for the birth of the son of King Herod."

CHAEL: "So these wise gentlemen found something they weren't expecting—that the liberator was a poor little child, and besides, a little child persecuted by the powerful."

Carlos García

Entering the house,
they saw the child with Mary his mother.
Matt. 2:11

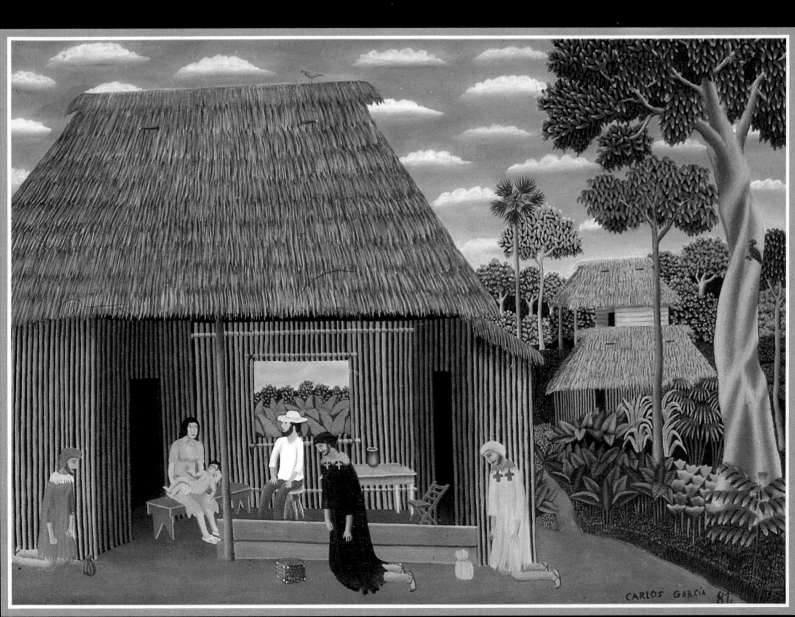

The Flight into Egypt

Matt. 2:13–15

Shortly before we had Mass this Sunday a National Guard patrol came to inspect our houses. (Martial law had been declared throughout the country, with a suspension of individual liberties.) Some people seemed to be a little afraid, but the children rushed gaily throughout the church and made so much noise that it was hard at times for us to hear clearly the commentaries on the Gospel.

Among those present was my brother FERNANDO (a Jesuit priest), and he said: "I think that if Mary, when she was waiting for the birth of the infant, had the idea of a Messiah who would be in power, she quickly lost the idea. She realized that she had given birth to a messiah who was subversive from birth. And I also think that for a long time we have been misreading the Gospel, interpreting it in a purely spiritual sense, eliminating all its political and social circumstances. How often have I read that Saint Joseph and the Virgin fled to Egypt. But only now, when an army patrol has just come, have I really understood that very real and harsh circumstance that the Gospel presents to us here: repression. We can imagine what this means: leaving at night, hiding, with great fear, leaving everything behind, and having to reach the border because they are being pursued."

ERNESTO: "There are many *campesino* families that have had to leave their homes in many parts of Central America, fleeing from misery and hunger, or because they have been driven off their lands, or because the National Guard is killing the *campesino* leaders, burning farmhouses, raping women, jailing whole families, torturing. And the picture of all those families fleeing, mothers carrying their children in their arms, is the same as the flight to Egypt."

DONALD: "Can I say something? You know what country we're in, and how there's so much infant mortality, and so many stunted, undernourished children. I think that's persecuting children. I think the same thing is happening here as happened to Christ when he was persecuted as a child."

OLIVIA: "The truth is that ever since he was at his mother's breast he had the rich against him. When she was pregnant Mary had sung that her son was coming to dethrone the powerful and to heap good things upon the poor and to leave the rich without a single thing. And from his birth they pursued him to kill him, and then he had to flee in his mother's arms and with his papa."

ELVIS: "Yes, that's just what goes on nowadays, and it's because anyone who is struggling for the liberation of the oppressed is himself a Christ, and then there's a Herod, and what we're seeing is the living story of the life of Jesus. And more Herods will come along, because whenever there's someone struggling for liberation there's someone who wants to kill him, and if they can kill him they will. How happy Somoza would have been if Ernesto and Fernando had died when they were little kids. It's perfectly clear that the business of Herod and Christ is what we have right here."

Miriam Guevara

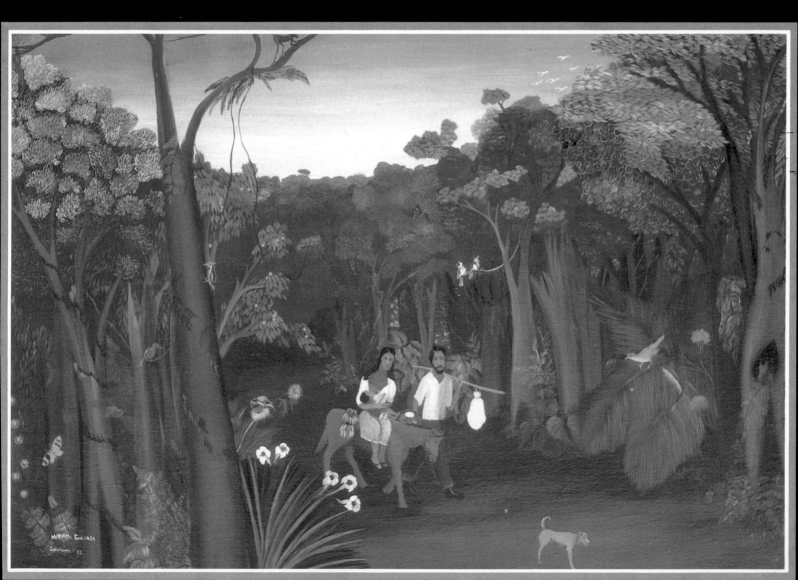

*Rise up,
take the child and his mother,
and escape with them to Egypt.*

Matt. 2:13

The Slaughter of the Innocents

Matt. 2:12–23

Old TOMAS: "Herod ordered the kids killed since he wanted to reign forever and didn't want a liberator."

FELIPE: "And the same thing happens here and in other places, wherever they're screwing the people. The innocent. Because the ones they are killing are the innocent. In all these cases they're killing the child that they don't want to see grow up. Back then something like that happened. Herod was the Somoza of that region, and when he heard that that child had been born, he went after all the children. As soon as they glimpse a sprig of liberation anywhere, they do what Herod did."

LAUREANO: "And not only that, because Herod killed them after they were born. Now they kill them before they are born with their famous Family Planning; they kill the children before they're born for fear that later there'll be a people that they won't be able to control."

ERNESTO: "That's very true, and there are clinics set up all through the country where they sterilize women without their consent. This is a campaign that the United States is waging throughout Latin America. They have population experts throughout Latin America, in charge of seeing that the population doesn't increase. President Johnson once said in a speech that bringing up a Latin American cost the United States two hundred dollars, while stopping him from being born cost only five dollars. And as an economist has said: If births decrease, funds for investment will increase."

OSCAR: "Ernesto, I want to say something. Do you know how I understand birth? The birth of a child is very important—I feel this deeply as the father of a family. But that's not the birth that this Gospel is telling us about. Do you know what I understand by a child here? It's the poor people! They are children with respect to the rich. I mean that we, then, since we're poor, we're children, we're always beneath the rich. It seems to me that's what this birth means, a little child who suffers. We ourselves, even though we're adults, are like children: the poor. But, the child is not always going to be tiny."

ALEJANDRO: "And that Jesus who was born in a manger, like a child is born here in the mountains, in a farmhouse or in a boat, is the liberation that's also being born here, in a humble form. And even in those kids who are still so young, who are playing here, and who have been born like this, inside them, even though they don't know it, something is born: freedom."

Julia Chavarría

18

and gave orders for the massacre
of all infants in Bethlehem.
Matt. 2:16

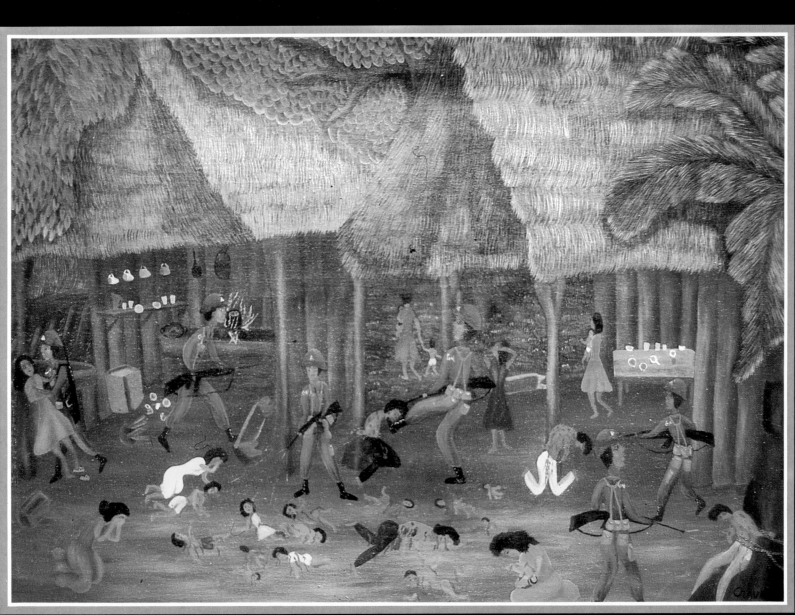

Jesus of Nazareth

Luke 2:41–52

When Jesus was twelve years old
they all went to Jerusalem
as was the custom of that feast.
And when they returned,
after the feast was ended,
the child Jesus stayed behind in Jerusalem;
and Joseph and his mother did not know this.

The young people began to talk. First MANUEL: "He disobeyed. He gave them the slip. And young people should disobey when their parents want to keep them just for themselves, when they want to take them away from the community, from their work with other young people, from their duty, from the struggle."

OLIVIA: "He also did it to help prepare them. He was going to be away from them later. And when Mary and his other relatives came looking for him, he told them that his family was the community. And then Mary lost him in death, but on the third day, like here in the temple, he was found. He went to the temple to teach the teachers of the law, because these teachers knew the law by heart but they didn't put it into practice."

ERNESTO: "Then the Gospel tells us that Jesus returned with Mary and Joseph to Nazareth, and all his life he would be called a Nazarene. Nazareth was a place so humble that it is not mentioned even once in the Old Testament. The name 'Nazarene' that Jesus had was a nickname given him by his enemies to make fun of his humble origin."

GLORIA: "To say 'from Nazareth' might be like saying 'from Nindiri' . . . or worse, 'from Solentiname.' "

Meanwhile Jesus went on growing
in body and mind.

FELIX: "He was developing in love. That was his growing up. He was maturing in his love for people."

OSCAR: "And he didn't just grow once. He grows and develops in a community every time that love and unity among everyone in the community develop and grow. And so now here among us Jesus is growing. He is developing and becoming a man."

ALEJANDRO: "And he chose the temple because it was the center of their religion. He went right to the root of it. Because since religion was corrupt, he wanted to attack the evil at the root, in the temple and with the leaders."

José Arana

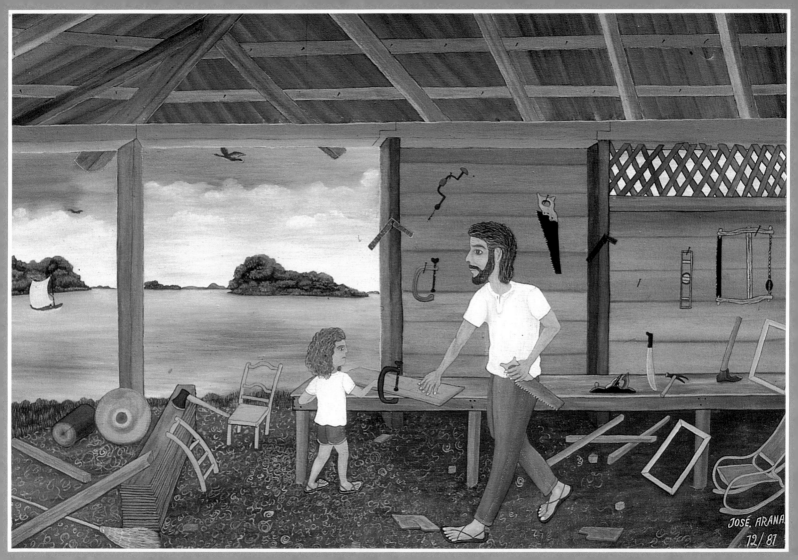

JOSÉ. ARANA
12/ 87

The Baptism of Jesus

Luke 3:1–20

ERNESTO: "Why was it that Jesus was baptized?"

MARIITA: "To give us an example. He didn't need baptism but we did, and he did it so we would do it when we saw that even he did it."

Old TOMAS: "Jesus was baptized probably out of humility. He was with his people, with his group, and he wasn't going to say: 'I don't need this, you do it, I don't have any sin.' The others, the Pharisees, might say that, the ones who didn't follow John. Not Jesus, he goes along with the others."

ALEJANDRO: "You could say out of solidarity. So he wouldn't be separated from the group."

> *And while he was praying,*
> *the heavens opened*
> *and the Holy Spirit descended like a dove*
> * in bodily form upon him,*
> *and a voice from heaven was heard saying:*
> *"You are my beloved son:*
> *I am well pleased with you."*

OLIVIA: "It wasn't that a dove descended, because it doesn't say that a dove descended but '*like* a dove.' A dove is a soft and loving animal. And the Holy Spirit is loving. It was the love of God that descended upon him."

ALEJANDRO: "In this way the Father wanted to make it clear that he was pleased that Jesus had been baptized. He also wanted to show the meaning of baptism, which is to receive the Holy Spirit."

TERESITA: "God acknowledges him as his Son, and in the same way he acknowledges us too when we're baptized, when we change our attitude, not when we're baptized just out of habit as is done throughout the country. And this baptism becomes a true one when you become an adult, when you can choose a change of attitude."

ERNESTO: "It seems that this baptism of Jesus was the beginning of consciousness of his mission as Messiah, and of being possessed by the Spirit of God or the Spirit of liberation. In the Old Testament it had been prophesied that that spirit would descend upon the Messiah, and that's what Luke said came down upon Jesus in the form of a dove. At other times Jesus spoke of his death as a baptism, or 'bath.' He means that his true baptism would be that of his death, his blood bath, and this is what he accepted when he accepted his calling as the Messiah."

Old TOMAS: "It is interesting that when he was filled with the Holy Spirit, he set out on no other journey. Instead he returned to his home, to the humble people where he had been brought up."

Esperanza Guevara

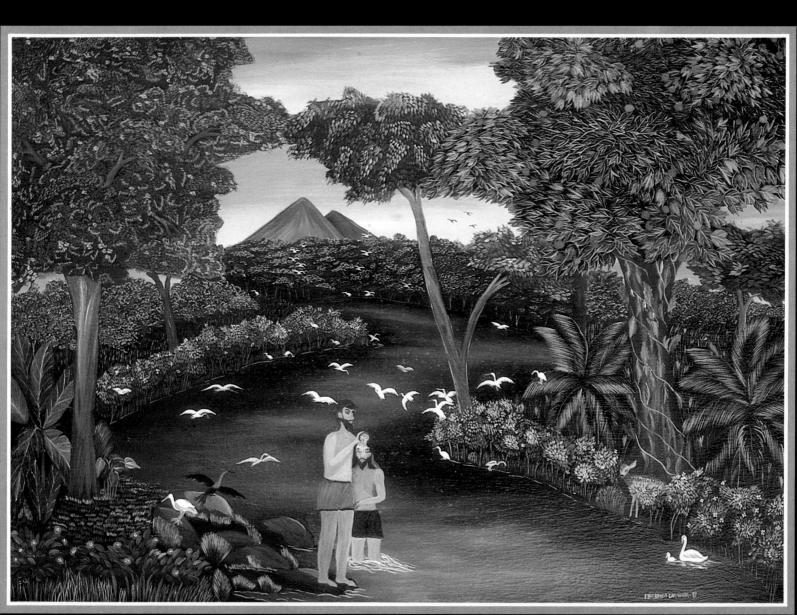

The Beheading of John the Baptist

Mark 6:14–29

John reproved Herod the governor
for taking as his wife Herodias,
the wife of his brother Philip,
and also for the other bad things he had done.
So Herod had John put into prison.

We read that John, when he was in prison, heard about the works of Jesus and sent his disciples to ask him:

Are you the one who is to come
or do we wait for another one?

OLIVIA: "I imagine John knew he was going to die. He knew the regime he was living under. And he asked that question so his disciples would know that there was going to be somebody else who would replace him, so they would know that the Messiah was already here. I don't believe he would have doubted. And he asked it so that the disciples wouldn't be discouraged when he died, for he had to die for freedom, and Jesus had to die for the same reason. Their fate wasn't to triumph but to die."

ALEJANDRO: "People frightened by the changes that Christianity is going through should pay attention to this. Jesus doesn't say to them: 'Notice that in such and such a place people are fasting, are praying a lot, are going to Mass every day'; he simply sends word to John that people are being cured, getting food, having their problems solved. He's saying that people are being freed."

MANOLO: "John was killed because he reproved the governor not only for adultery but also for all his tyrannies and his crimes. That's what it means here by 'for the other bad things he had done.' He couldn't preach about a change of attitude without touching the person of Herod."

FELIPE: "And when the priests and bishops keep prudent silence in the face of the crimes that happen in this country, because they say it is not proper for them to get involved in politics, they simply aren't following this example from the Gospel."

An elegant lady from Managua was with us: "But don't you think that John would have been of more use to humanity if they hadn't put him in jail and killed him?"

TERESITA (holding her son Juan in her arms): "If he had kept silent he wouldn't have done any good. Martyrs may have been very useful during their lives, but they've been more useful to humanity as martyrs."

FELIPE: "He gave his message even better with his death than with his life."

Esperanza Guevara

*I want you to give me
the head of John the Baptist on a platter.*
Mark 6:25

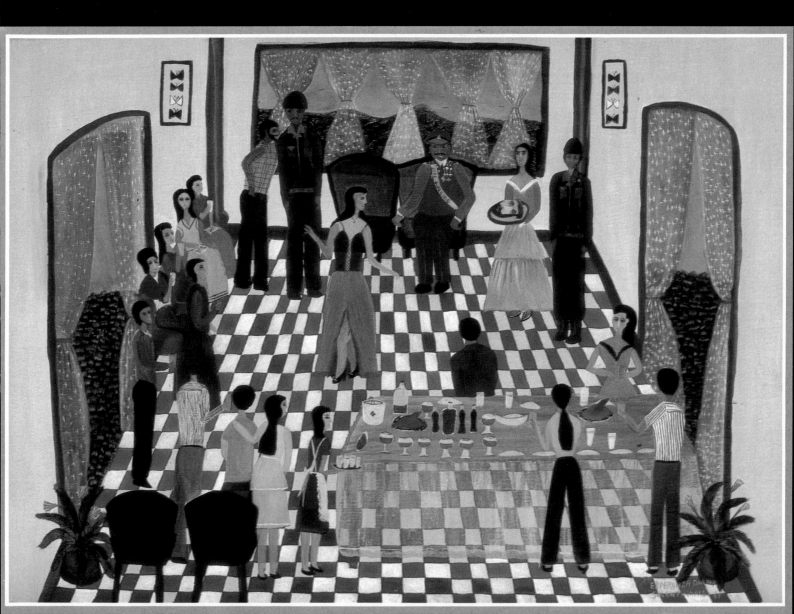

Call of the First Disciples

Luke 5:1–11

We had gone to celebrate the Eucharist on Deer Island, and we were gathered in the open air near the hut of a *campesino,* with the lake in front of us, deep blue, and our boats very close to us tied to the shore. A boy from Deer Island had read Luke's Gospel about the miraculous catch of fish and the calling of the first disciples.

Old TOMAS, a great fisherman: "He looked for country people and fishermen to do his work, not aristocrats. The workers are the ones who really transform the world and are called to be the masters of the world—even though a lot of them don't know it; but Jesus, he knew it."

DON JULIO, also a famous fisherman: "So they in turn could look for other humble people that nobody paid any attention to before. People who didn't count for anything. Just like Jesus told Peter to cast the net where he thought there was nothing, and Peter came up with a terrific catch."

OLIVIA: "Think of this: All us gathered here used to be scattered, with our own selfishness and individualism, slipping away from each other, as slippery as fishes. . . . We're the miraculous catch."

Then when they brought the boats ashore,
they left everything
and went away with Jesus.

DOÑA ANGELA: "They let themselves be caught by him."

ALEJANDRO: "That was the miraculous catch, and not the haddock and shad and all the other different fish they caught with the net. And they caught us and that's why we're gathered here, as Doña Olivia says."

MARCELINO: "Because they left their belongings right there, the word of God came to these islands."

DON JULIO: "Before we used to be only fishers of fish from the lake here, but now we can be fishers of men too, if we get rid of our belongings."

FELIPE: "I think that since we are going to be fishermen, we have to be careful not to want to fish for our own personal interests. The catch of Jesus Christ is for the good of humanity. It's the catch of love."

When we finished, a fresh breeze was blowing from the south and the lake was beginning to ripple.

Gloria Guevara

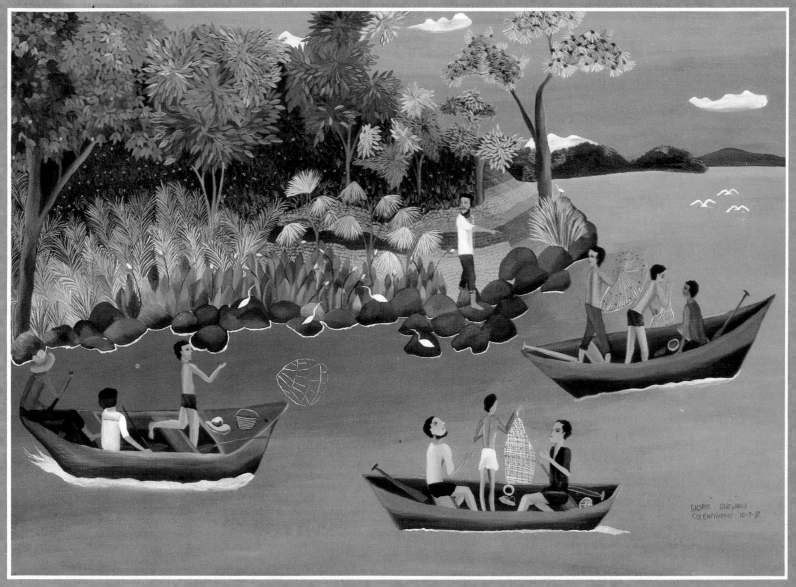

Jesus Calms the Storm

Mark 4:35-41

This Sunday's Gospel is very important to us because three days ago Ivan, Bosco, and their mother had their boat capsize. They spent more than two hours out in the middle of the lake, clinging to the overturned boat, until they were rescued.

NATALIA: "Faith is what's important. I'm thinking of the boat that sank here—the anguish of Doña Chalia in those huge waves. She can't even swim, the same as me because even though I live here I don't know how to swim. It must be frightening to fall into the water in the middle of the lake, without knowing how to swim."

BOSCO: "I think faith is what saves you. There I was in the water. I knew that the lake was deep, but I had faith in God. I said, 'Son of a bitch, God, if I'm going to be of any use to anybody, I can't drown!' And my mama was shocked and said, 'You're swearing!' It's one thing to be inside the boat, and it's another very different thing to be outside the boat. Outside the boat you drown. Outside the boat, if you lose faith, you drown."

CHEPE, Ivan's brother-in-law: "I think Jesus went to sleep on the disciples to teach them how to behave when he wasn't there—like he would be sleeping afterwards when he died."

ALEJANDRO: "I agree with Chepe, and this applies to us in many things that have nothing to do with boats or waves, in other kinds of storms that we have. The lack of love in the world, that's the stormy lake."

FELIPE, who found the overturned boat this morning: "Faith is the faith that many young people have today. It's faith that the world can be changed by love, that evil can become good, that those angry waves can be calmed."

OLIVIA: "The greatest evils of humanity are due to lack of love, and God doesn't solve them personally. He does it through love among people. We used to be content with faith in a Jesus in Heaven, who isn't the one who's in the storm, the one who is here with us in the person of the other, in so-and-so, in what's-her-name, the Jesus who's with the people, even though he seems asleep."

ADAN: "I think that now a lot of people don't believe anything. Maybe even most people. Even the most religious people, they don't believe either. They are absolute unbelievers; I've seen it. They say you can't make any changes here. And many talk against it. The Christian who doesn't believe in change is a Christian without faith."

FELIPE: "The storm is the attacks of the enemies of this gospel message. And we shouldn't be afraid. We must have faith, as Jesus said that time to the men who were in a boat with him."

OLIVIA: "He travels with us in the community. The boat is the community."

Ignacio Fletes

28

He said to them,
"Why are you fearful,
O you of little faith?"
Matt. 8:26

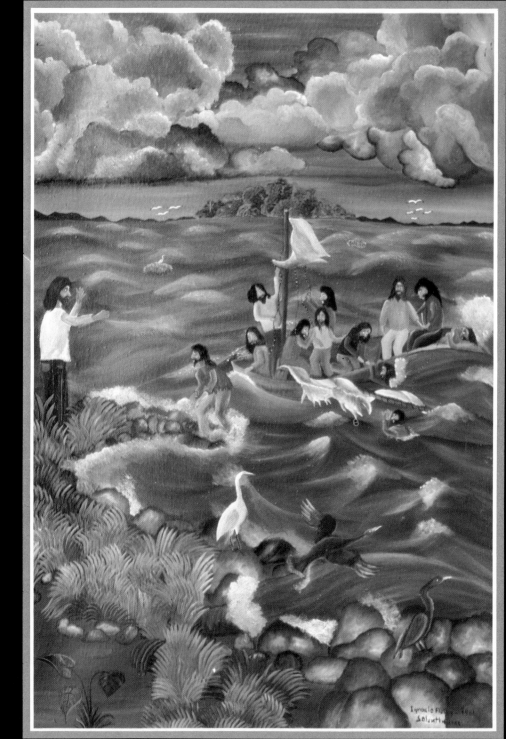

The Wedding at Cana

John 2:1–12

. . . Jesus' mother said to him:
"They have no more wine."
But Jesus answered her:
"Woman, why do you tell that to me?
My hour has not yet come."

OLIVIA: "His hour was the hour of his death. He shouldn't be performing miracles yet, presenting himself as the Messiah who was coming to do good and to liberate the people, because then the powerful would kill him. That's why he says to her: 'Woman, stop bothering me, my hour hasn't come yet.' "

MARCELINO: "Following up on what Olivia said, I see that Mary's attitude is a good example. Jesus may have been afraid. It's very natural for somebody to be afraid of death. Later he was afraid in the garden when his hour came. Or maybe it was just prudence. It's all the same. But anyway Mary here doesn't seem to be afraid or to pay any attention to prudence, but she urges him to perform the miracle. He didn't want to get into being a Messiah yet, and she pushes him into it. It seems like she's saying: 'It doesn't matter if they give us a hard time.' And she calls the servants."

Jesus said to the servants:
"Fill these jars with water."
The man in charge of the party
tasted the water that had turned into wine.

OSCAR: "It seems to me that the wine means joy, a party. To be happy. Enjoyment. Also love."

ERNESTO: "In the Old Testament the messianic era had often been described as an epoch of great abundance of wine. The prophet Amos had said that when the Messiah came there would be great harvests of wheat and grapes, and that the hills would distill wine. By this miracle Christ is making it clear that he is the promised Messiah."

MARCELINO: "He was coming to bring unity and brotherhood among people. That's the wine he brought. If there's no brotherhood among people there's no joy. A person's birthday or saint's day is not a happy party if there's division."

TERESITA, William's wife: "But it wasn't at any old party that he performed the miracle. It was at a wedding party."

ERNESTO: "It had often been prophesied also that the messianic era would be like a wedding with God."

FELIPE: "No one will be excluded from that wedding. That will be true social justice."

Esperanza Guevara

*Jesus said to them,
"Fill the jars with water."*
John 2:7

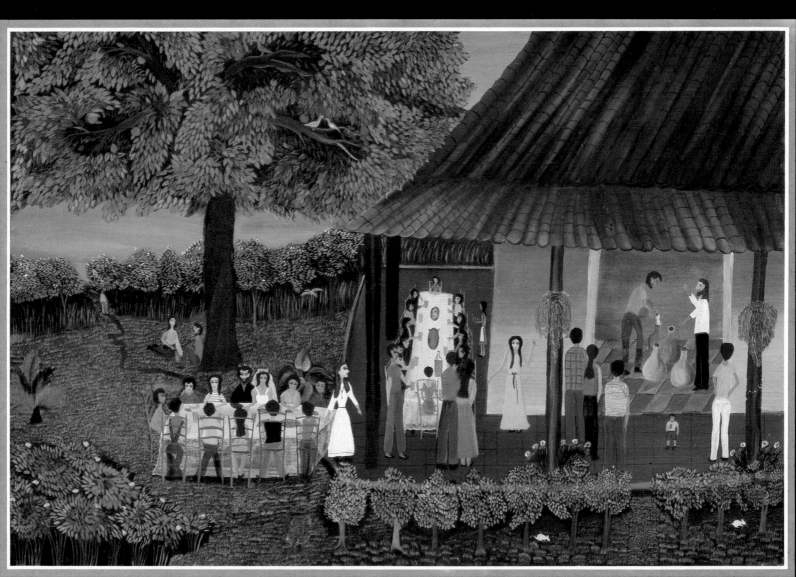

The Lord's Prayer

Matt. 6:7–15

When you pray,
do not talk a lot.

ERNESTO: "The translation is rather: 'Don't go blah-blah-blah-blah.' The Greek word that Matthew uses is *battalogein,* which is like saying 'blah-blah-blah-blah.' "

We went on to comment on the first words:

Our Father who are in heaven.

ERNESTO: "Jesus didn't really use the word 'Father.' Jesus said in Aramaic (his mother tongue) *Abba,* which is 'papa,' and that was probably the word he always used in speaking of God."

OLIVIA: "It's a loving name that's given to God. And from the very beginning we don't have to be formal when we chat with him and we give him the name of papa. So then to pray isn't to recite prayers but to chat with him."

Holy be your name.

ERNESTO: "For the Jews 'God' was the same as saying holiness or justice."

FELIPE: "To make something holy then doesn't mean to chant, to say prayers, to have processions, to read the Bible. Making the name of God holy means to love others, to do something for others."

May your kingdom come . . . your will be done
on earth as it is in heaven.
Give us this day the bread we need.

WILLIAM: "We pray to God for his name to be holy, and it's up to us to make his name holy. We pray for his kingdom to come, and it's up to us build it. We pray that his will be done on earth, and it's up to us to do his will. We pray to him for bread, and it's up to us to make it and share it. We pray to him for forgiveness, and it's up to us to forgive. We pray not to fall into evil and it's up to us to escape from it. That's what's interesting about this prayer. I think that a lot of people don't say the Lord's Prayer, but in their hearts they're asking for all this."

ERNESTO: "This is the prayer we should have. It's the one that Christ said on earth and the one that, according to Saint Paul, he goes on saying in our hearts."

We ended by reading what the Letter to the Galatians (4:6) says: "As we are his children, God sent into our hearts the Spirit of his Son, crying: '*Abba,* Papa!' "

Pablo Mayorga

As he was praying, one of his disciples said to him,
"Lord, teach us to pray . . ."
Luke 11:1

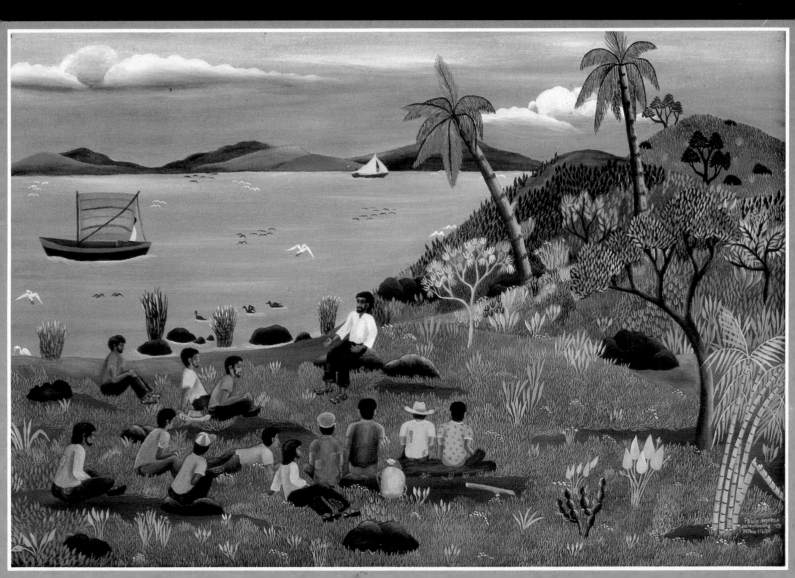

The Beatitudes

Matt. 5:1-12

ERNESTO: "In the Bible the poor are often called *anawim,* which in Hebrew means 'The poor of Yahweh.' They are so called because they are the poor of the liberation of Yahweh, those that God is going to liberate by means of the Messiah. It's like what we now understand as the 'oppressed,' but in the Bible those poor people are also considered to be good people, honorable, kindly and holy, while their opposites are the oppressors, the rich, the proud, the impious."

OLIVIA: "The poor in spirit or the poor in God are the poor, but provided they have the spirit of the oppressed and not of the oppressors, provided they don't have the mentality of the rich."

Old TOMAS: "Because we poor people can also have pride, like the rich."

ALEJANDRO: "What we see here is that there are two things. One is the kingdom of God, which is the kingdom of love, of equality, where we must all be like brothers and sisters; and the other thing is the system we have, which isn't brand new, it's centuries old, the system of rich and poor, where business is business."

ANGEL: "That's why it seems to me that we have to interpret carefully. If we just stick to the fact that we're poor and God has said that the kingdom of God is for the poor, then we'd end up saying that, well, because we're poor we already have the kingdom of God and we can do anything."

ERNESTO: "I've just had a visit from a young fellow from the north, from Estelí, from a poor town. He is a *campesino*—like yourselves—and he was saying that there to get together for their Masses, first they have to ask permission from the police, and the police captain said that those gatherings were dangerous. The captain is right, for they gather there to talk about the Gospels. Those Christians of the earliest Jewish community, who had taken the name *anawim* before they were called Christians, were so called not only because they were poor but also because they were persecuted. Because 'poor of Yahweh' (or 'poor in spirit' in these Beatitudes) is the same as saying persecuted."

TONO: "That didn't use to happen here because the Masses were in Latin. The priest read these things but he read them in Latin, and he didn't explain them to the people. So the Gospels didn't bother the rich or the military."

Marina Silva

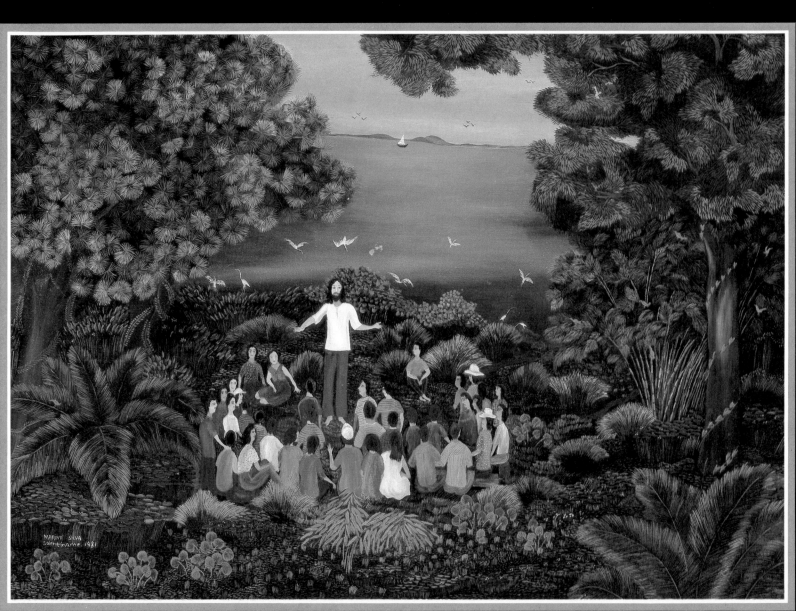

The Rich Epicure and Poor Lazarus

Luke 16:19–31

It's the parable of the rich man who had parties every day, while the poor man was at his door covered with sores.

FELIPE: "I think the poor man here stands for all the poor, and the rich man for all the rich. The poor man is saved and the rich man is damned. That's the story, a very simple one, that Jesus tells us."

GLORIA: "The rich man's sin was that he had no compassion. Poverty was at his door, and that didn't disturb him at his parties."

WILLIAM: "The traditional interpretation of this passage is wrong and is used for exploitation; because the poor man has been led to believe that he must patiently endure because after death he's going to be better off and that the rich will get their punishment."

FELIPE: "As I see it, this passage was rather to threaten the rich so they wouldn't go on exploiting; but it seems it turned out the opposite: it served to pacify the people."

OLIVIA: "I think the word of God has been very badly preached, and the church is much to blame in this. It's because the Gospel hasn't been well preached that we have a society still divided between rich and poor. There are few places like Solentiname where the Gospel is preached and we understand it. Also, it's we poor people who understand it. Unfortunately, the rich don't come to hear it. Where the rich are, there's no preaching like that."

MARIITA: "The rich man's sin was not sharing—not sharing with everybody, that is, with the poor, too; because he *did* share with the rich: the Gospel says he gave parties every day."

JULIO: "They weren't inviting the poor; they'd get their houses dirty."

ERNESTO: "I believe this parable was not to console the poor but rather to threaten the rich; but as you said, William, it has had the opposite effect, because the rich weren't going to heed it. But Christ himself is saying that in this parable: that the rich pay no attention to the Bible."

OSCAR: "It seems like it doesn't do any good to be reading the Bible, then, because if you don't want to change the social order, you might as well be reading any damned thing, you might as well be reading any stupid book."

ERNESTO: "It seems to me that Jesus' principal message is that the rich aren't going to be convinced even with the Bible, not even with a dead man coming to life—and not even with Jesus' resurrection."

José Arana

There was a certain rich man . . .
who feasted every day in splendid fashion.
Luke 16:19

The Good Samaritan

Luke 10:25–37

A teacher of the law stood up and said to him,
to lay a trap for him:
"Master, what must I do to win eternal life?"

MANUELITO: "They believed in a heap of religious rules, and they wanted to see if Jesus said they had to follow them; if he said they didn't, he set himself against the law."

ALEJANDRO: "It seems to me that what was happening then with the law is happening now with the Gospel: the law was extremely clear, but they didn't understand it, and according to them they were following it. And they hope that Jesus will speak against the law, as they understand it, so they can condemn him."

ERNESTO: "I see. It's as if a supporter of this regime should ask us what we think of the Gospels. That could be a dangerous question, couldn't it?"

Jesus answered him:
"What is it that is written in the law?"
The teacher of the law answered:
"Love the Lord your God with all your heart . . .
and love your neighbor as you love yourself."

WILLIAM: "Maybe he wanted to argue with him about worship in the temple, the sabbath, unclean food, purification, and many other laws that were nonsense, and Jesus makes him say what's important: loving God and your neighbor."

But he, trying to defend himself, said to Jesus:
"And who is my neighbor?"

We read the parable. A man was assaulted by thieves and left wounded on the road. A priest and a Levite passed by. A Samaritan took care of him and took him to an inn.

"Well, then, which of those three does it seem to you
was the neighbor of the man assaulted by the thieves?"
The teacher of the law said:
"The one who took pity on him."

OLIVIA: "He gave them as an example a person of another race and another religion so we can know that everyody in need is a neighbor."

ALEJANDRO: "The priest and the Levite really didn't love God because they didn't love their neighbor, and as we see, the law of the two loves is a single law. They were only 'religious' people; they devoted themselves only to their prayers. So maybe that's why they didn't stop on the road; they were in a hurry to get to their temple duties. It was religion that prevented them from loving their neighbor, and that kind of thing is still going on."

Rodolfo Arellano

"Which of these proved himself neighbor to him who fell among the robbers?"

Luke 10:36

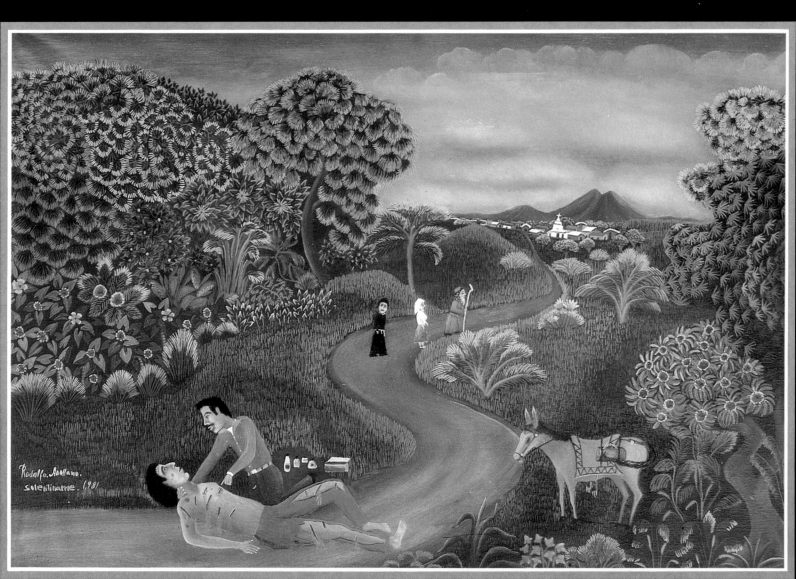

The Parable of the Sower

Matt. 13:1–13

ERNESTO: "You are *campesinos* and you will be able to understand very well this parable of the seed."

DON JOSE: "The seed is a living thing. You don't sow dead seeds. And so, as I see it, the message is a living thing."

OSCAR: "The seed is also something to eat. People sow grains that feed us. The words of Jesus are grains that he scatters in the wind, to feed us all."

DONALD: "The seed is a tiny, wrinkled, ugly thing, and anyone who doesn't know better might think that it's useless. And it's the same with the word of God, it seems to me, when the person that receives it doesn't know what it contains."

WILLIAM (with his son Juan in his arms): "And there's another special thing about the seed, as I see it. It's not only a living thing but it's the transmission of life."

NATALIA, the midwife: "We are all seeds. Seeds who produce more seeds."

OSCAR: "Christ rose from the dead because he was a healthy seed. In the harvest we have seen that not every seed is born but only the good seeds, the nice healthy ones. And so, if we're going to rise from the dead like Christ we must be the same kind of seed that he was."

OLIVIA: "I think that Jesus spoke of the seed because he was talking to us *campesinos*. If he had been talking for the rich he would have used examples that they would have understood very well. But he used this example of the seed because he was talking our language. He was talking about seeds and birds that eat the grains and plants that die of oversoaking and of swamps, because that's our language."

Old TOMAS: "And when we hear the message and we forget it, it's like the corn that the birds ate. You sow now, and tomorrow when you go to look there's nothing at all. The birds ate it all. The birds are the devil that carried off the message that had been sown."

MARCELINO: "These words about the seed that we are hearing here are that same seed, and maybe we hadn't realized it. If we hear these words the seed of the kingdom is buried in us, he says. But he speaks of the kingdom only for those who have ears."

JULIO: "I see one thing. The seed alone, without the land, doesn't do anything. So this doctrine without us is of no use. Without us there is no kingdom of heaven."

Rodolfo Arellano

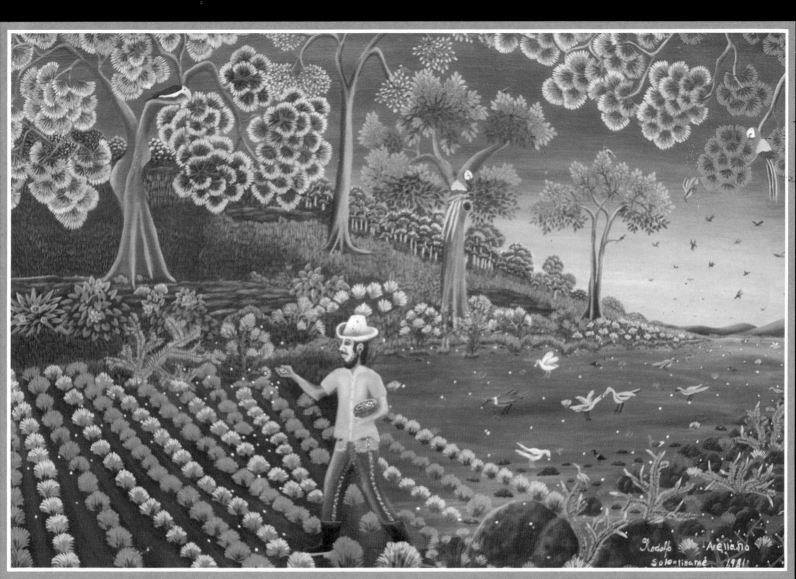

The Multiplication of the Loaves

Luke 9:10–17

Night was approaching. Jesus had been talking all day about the kingdom of God. The apostles asked him to dismiss the people for this was a remote area where there was no food.

JULIO MAIRENA: "The apostles think there isn't any food, and it seems to me that's the way it is now. We all say we don't have any food. It's that a few people have it all. If it was all shared around we'd all be eating what those few who have the food are now eating, and I think we'd all have enough."

PANCHO: "I'm just catching on to what this means here! They didn't have enough—right?—to feed the five thousand people. But then he says to them: It doesn't matter, share it. And there was more than enough! He made them understand that no matter how little they had they had to share it. And they shared it, and with his power he made it stretch out. The lesson is that no matter how little we have we always have to give."

ALEJANDRO: "As I see it, the same thing didn't happen to Jesus that almost always happens to the church: that it's nothing but words—that we must do good and all that. But when people are hungry, nothing is done to solve the problem. Christ not only uses words, talking to them all day about the kingdom of God, but he feeds them through his disciples. He doesn't send them away hungry. Christ's gospel also feeds you. But many bishops and priests think it's only to save your soul and not to change the economic situation of society."

FELIPE: "A lot of people think things are the way they are because God wants them to be that way. He made people rich and poor, and until he wants it nothing's going to change. And that's not true. He's given us the order to change things. We have to feed the hungry, and God will give us the power to make miracles as he gave it to his disciples."

ESPERANCITA, Olivia's daughter, pregnant with her first child: "About the fish and the loaves that were so small and they increased and got bigger: that can also be a community that's born tiny and grows and gets to be big because inside it consciousness is growing and love is growing and it gets to be the size of the whole country. I see that in the number of loaves and fishes that it says."

WILLIAM: "This has always been called the Miracle of the Multiplication of the Loaves, but I see that the gospel doesn't mention multiplication or miracle. It just says that they shared them. The miracle was to persuade the owners of the bread to share it, that it was absurd for them to keep it all while the people were going hungry."

Pablo Mayorga

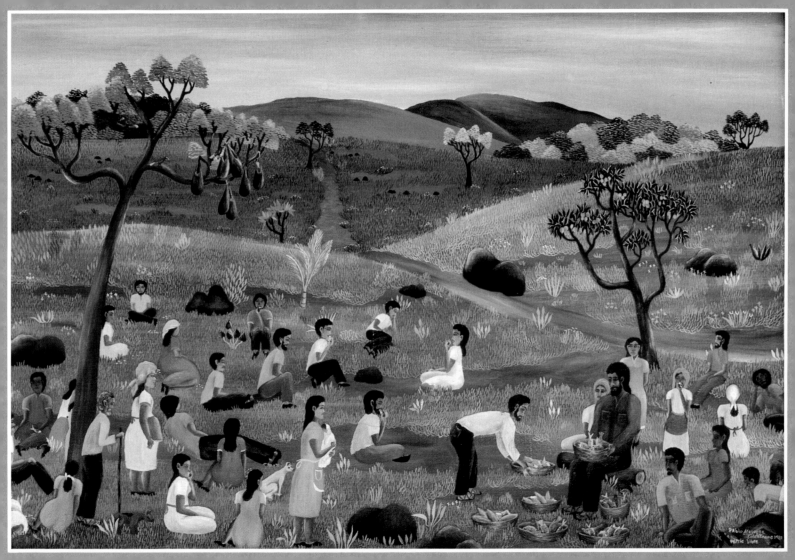

Mary Anoints the Feet of Jesus

John 12:1-8

Then one of his disciples, Judas Iscariot,
he who was about to betray him, said:
"Why was this ointment not sold
and given to the poor?"

OSCAR: "If they'd sold it, it would have gone to only a small number of the poor, and the poor of the world are countless. On the other hand, when she offered it to Jesus, she was giving it, in his person, to all the poor. That made it clear it was Jesus we believe in. And believing in Jesus makes us concerned about other people, and we'll even get to create a society where there'll be no poor. Because if we're Christians there shouldn't be any poor."

TERESITA: "It's possible that he'd done her some favor, some miracle, and the only way she found of thanking him was to perfume him."

ERNESTO: "It seems that this girl is the same Mary Magdalene out of whom Jesus cast seven devils."

JOSE (María's husband who works in the San José Bank): "But Jesus hasn't forgotten the poor, because notice that in the following verse he says they will always have the poor among them. He means that if they want to help the poor they can be helping them a lot, later. They'll have the opportunity to give everything to the poor."

Jesus heard this and said to them:
"Why do you bother this woman?
This thing that she has done is a good thing.
The poor you will always have among you,
but you will not have me."

WILLIAM: "This is a phrase much used by conservatives to say there'll always have to be poor people, because Christ said so. The world can't change, because according to Jesus there'll always have to be rich and poor."

Old TOMAS: "There's lots of ways of being poor: a poor person can be somebody with an arm missing. A poor person is somebody born stupid, or an orphan child, without parents. These will be in the community. There'll always be people like that in need, but of course if we're Christians they won't be poor, in poverty; if they're among us, that is, we won't let them perish."

ERNESTO: "I think what he's saying is that he's going away but that in place of him the poor are left. What that woman was doing with him, they'd have to do later with the poor, because he wasn't going to be there any longer, or rather, we were going to have his presence in the poor."

FELIPE: "And people like us who don't have perfumes or luxurious things to give because we're poor—we can give other valuable things that we have. We can offer our lives as Jesus did."

Rodolfo Arellano

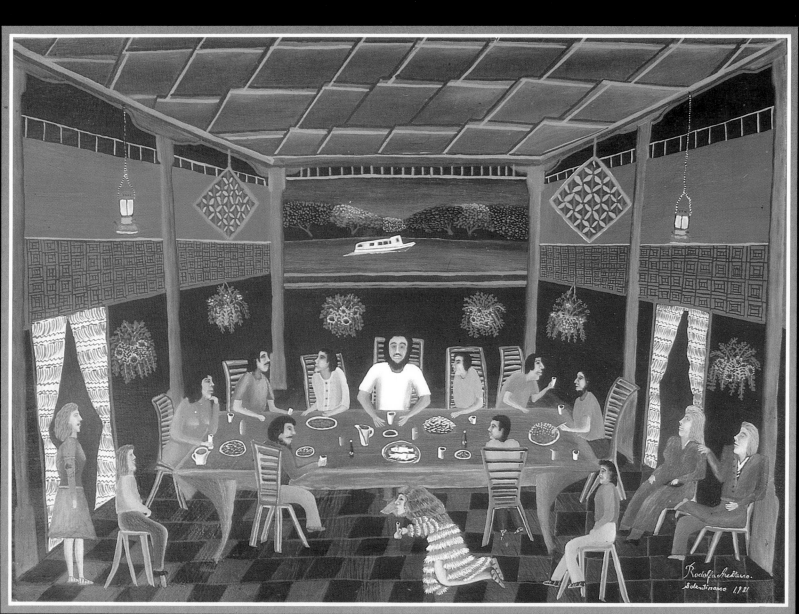

Jesus and the Samaritan Woman

John 4:1–42

"Give me water."
Then the Samaritan woman said to him:
"How is it that you, who are a Jew,
ask me, a Samaritan, for water?"

LAUREANO: "There's a lesson in the fact that he went to ask a woman of an enemy people for water. For Jesus there were no divided peoples. And he teaches us not to be divided by nationalisms."

ERNESTO: "He didn't care about religious differences either. The reason why the Jews had no contact with the Samaritans is because they were of a different religion."

Then Jesus answered her:
"If you knew the gift of God,
and who it is that is asking you for water
you would surely ask me,
and I would give you the water of life."

OSCAR: "It was there that she recognized it wasn't an enemy that was talking to her, but that what she needed, which was love and peace, he was giving to her."

OLIVIA: "People who sin do it out of desire, because they're thirsty, for all desire is a thirst. And he was going to put an end to that thirst; she was going to be satisfied."

For the water that I shall give them
will gush forth like a spring within them
to give them eternal life.

OLIVIA: "He says the water he will give will gush forth inside of you. He gives it but it's born from us. It's God's very life that he'll give us, which is love, and that's what he calls eternal life, because it's God's life. But it's going to come out of us, it won't be stagnant; it'll be a fountain, a fountain of life."

ELVIS: "All those people who are struggling for freedom are carrying the water of life everywhere like a fountain. Freedom is like a river of life for humanity that empties into eternal life."

ALEJANDRO: "Freedom as an idea comes from the Jewish religion. It comes in order to spread everywhere. Freedom is for everybody, people of all religions and people without religion, too."

ERNESTO: "The whole Bible is a constant denunciation of injustice and a constant defense of poor people, widows, orphans; and it is constantly setting up the goal of humanity, a perfect society. That's the difference between the Bible and all the pagan religions, which considered the world as finished, unable to change, and they were on the side of the status quo, oppression. Although in practice, when the Jews were unfaithful to the God of the Bible, they also had an alienating religion, allied with power. And that's what Christ came to fight against."

Olivia Silva

There came a Samaritan woman to draw water.
Jesus said to her, "Give me to drink."
John 4:7–8

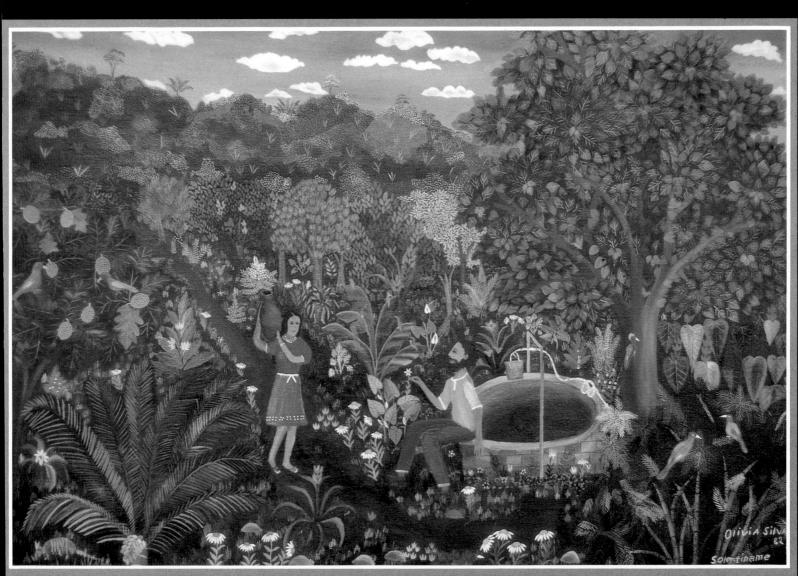

Jesus Enters Jerusalem

Matt. 21:1–11

Say to the daughter of Zion:
Look, your king comes to you;
he is humble, he rides on a donkey . . .

WILLIAM: "Jesus entering Jerusalem on a donkey was the fulfillment of the prophesy of Isaiah."

ALEJANDRO: "He has entered Jerusalem acclaimed as king. But he entered as a humble king, on a working donkey, not in a fancy automobile. And the new leaders now also come in poverty, preaching hard work and equality."

Old TOMAS: "They didn't expect that a king could come in on a donkey. On a donkey there ought to be a *campesino*."

ALEJANDRO: "All that business about being received in Jerusalem like a leader, with a political rally in the streets, with banners (branches were like banners), that must have upset the authorities a lot, and they decided to get rid of him."

ERNESTO: "And on Good Friday Pilate will tell them their king is a subversive—outside the law—and that his crime was a political crime. That means that we Christians must follow his example and be subversives. Now in Holy Week they're preaching a lot of sermons, but most of them won't be subversive. On the radio you can hear a sermon on the Seven Last Words. But it's sponsored by Coca-Cola."

Hosanna to the son of David!
Blessings on him who comes in the name of the Lord!
Hosanna in the highest heavens!

ERNESTO: " 'Hosanna' is a Hebrew word that is equivalent to 'Hurray,' and it literally means 'Free us, then!' It was a shout of acclaim for a leader. They are shouting 'Hurray for King Jesus.' "

WILLIAM: "And 'Son of David' refers to the Messiah. For the first time Jesus permits a public manifestation to honor him as the Messiah."

ERNESTO: "What the people are saying here is that Jesus has been anointed king and that he comes to free the people and to establish the Kingdom of God."

OLIVIA: "That's very different from what the rest of the people had been saying, that he was a new prophet. Because prophets used to announce the kingdom, while with Jesus the kingdom came."

ELVIS: "The Kingdom began but it's still a long way from being established throughout the earth."

OSCAR: "But that day is closer and closer."

José Faustino Altamirano

"Blessed is he who comes as king,
in the name of the Lord!"
Luke 19:38

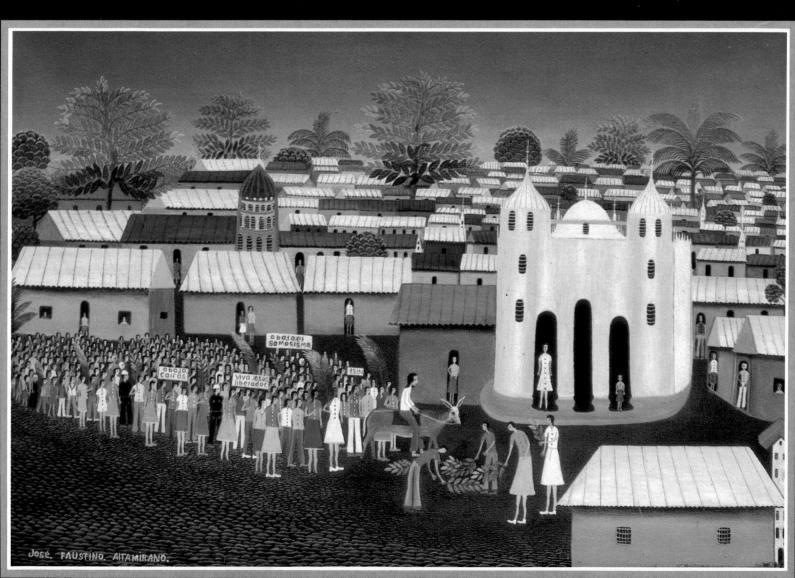

Jesus Drives the Merchants from the Temple

Matt. 21:12–17

Afterwards Jesus went into the temple and threw out
all those who were selling and buying there.

OLIVIA: "I think he drove them out because they were exploiting people, and not because they were profaning the temple with cows and other animals. The desecration of the temple was the exploitation."

GLORIA: "And, as I see it, that action was against all those people that trade with religion."

WILLIAM: "And in general against all the people who have made use of religion, of the various religions down through history, to maintain a system of exploitation."

OSCAR: "The temple ought to be a place of unity, where God would be present among them, and if there was exploitation it wasn't a place of unity anymore. That trading was against love, and God couldn't be there anymore."

. . . and when the chief priests and the teachers of the law
heard how the children were shouting in the temple:
"Hosanna to the Son of King David!"
they said to him:
"Do you hear what they are saying?"

ERNESTO: "The Gospel has said that it was with that shout of 'Hosanna' that they had greeted him the day before in Jerusalem. It was probably those same 'children,' the young people, who were the principal ones to acclaim him as king."

ALEJANDRO: "The young people were with him. And that made the leaders really mad."

JULIO: "I see young people shouting now as they shouted when they were with Jesus in the temple. The young people now want a change too, and this shouting is not pleasing to the rich, the ones who are enjoying their privileges, and so they try to shut them up. They really don't want to hear the young people shouting 'Hurray for change! Hurray for joy!' Because they seem to want to have oppression and sadness."

Mariíta Guevara

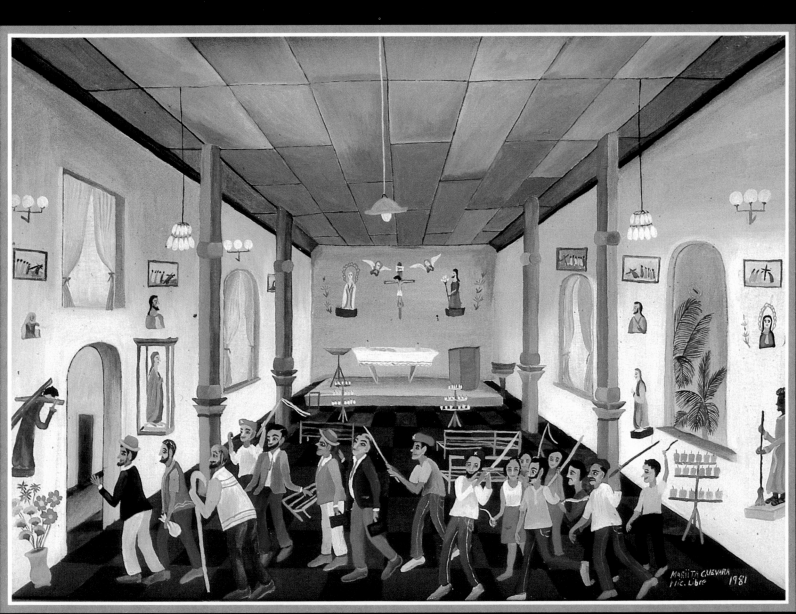

The Eucharist

Mark 14:12–25

We commented on this Gospel at Holy Thursday Mass at about five in the afternoon. With us was a great Nicaraguan composer of popular songs and protest songs: Carlos Mejía Godoy, who was going to perform for the first time his "Peasant Mass," which he had composed here in Solentiname. His presence had brought many people, especially young people. And we knew that some spies had also come. The disciples asked Jesus where they were going to celebrate the Passover.

OLIVIA: "It seems he was trying to see that nobody knew where it was going to be, that even the disciples didn't know, above all because he no longer trusted Judas."

WILLIAM: "That Eucharist was a clandestine supper, and besides, some of the disciples were armed, as the Gospel says also in another passage. The Passover supper was a commemoration of the Exodus, the liberation of the people, and here Jesus is beginning another Exodus, another liberation. And an authentic Eucharist, as long as there's injustice, has to be more or less underground—like this one that we're celebrating today."

ERNESTO: "At this Passover Christ did something different, like Moses. He began a new Exodus, and he established a new alliance of the people with the force that freed it from Egypt, for a new liberation."

While they were eating, he took the bread,
pronounced the thanksgiving,
and, after dividing it, gave it to them, saying:
"Take, this is my body."
Then he took a goblet,
and, after the thanksgiving, gave it to them,
and all drank from it.
And he said to them:
"This is my blood which confirms the new pact,
and which is shed for the good of everyone."

WILLIAM: "It seems to me that when he gave them that communion of bread and wine, the bread that is food and the wine that is joy, telling them it was his body and it was his blood, and 'go on doing this,' it was so that we would also repeat his sacrifice for the cause of the poor—that is, giving his life. 'This is my body' was equivalent to saying, 'this is my life,' and the same with blood. And he adds: 'my blood shed.' That's what he wanted us to repeat, not to repeat a ritual."

MARIITA: "He also said we'd see him in our neighbor, especially in the poor, in the people. He said, 'The poor are me.' And for that too you need a great faith. There are people who believe that Christ is in the host that they eat, and they don't believe in the Christ that's us."

Milagros Chavarría

*Jesus took bread, blessed it,
broke and gave it to them, and said,
"Take, this is my body."*
Mark 14:22

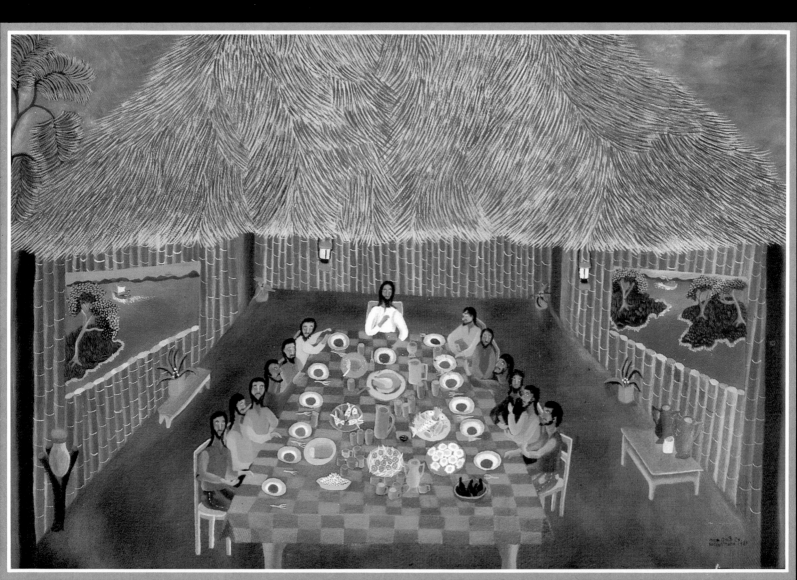

The Betrayal

Matt. 26: 36–56

Jesus arrived with his disciples at a place called Gethsemane.
He said to them:
 "Sit here while I go ahead to pray."

ERNESTO: "He was in hiding there. He was already underground. He had just celebrated Passover secretly in Jerusalem. Judas revealed the place where he was hiding."

 "Father (Abba—'papa'), if it is possible,
 take from me this cup,
 but it is not what I want but what you want
 that should be done."

GLORIA: "The Papa is love, and that is the only will that he respects. He only wants to love what love loves."

OLIVIA: "The Father has given that token to the Son, the token of love. Because he wants liberation, and liberation could come only through his death. Society couldn't be changed, the world couldn't be changed, made different without that death. Death horrifies everyone; he felt that horror; he wanted another way out, but there was no other way out."

We read that later Jesus found them asleep, and he said to Peter:

 "Be wakeful and pray so that you will not fall into
 temptation."

LAUREANO: "The temptation to not give his whole self, to want not to die and to remain withdrawn without doing what he had to do."

ERNESTO: "Jesus was having that temptation, and that's why he was praying."

Afterwards they come to arrest him, and Judas kisses him.

 Jesus said to him:
 "Friend, why do you come?"

TERESITA: "Why would he call him friend?"

SERGIO RAMIREZ (who had recently published a biography of Sandino): "When they were taking Sandino to be shot at Somoza's orders, Sandino said: 'But we're friends; I've just had supper with him, he gave me an inscribed photograph.' "

LAUREANO: "And Somoza embraced Sandino before he killed him. The traitor's embrace. Here it was a traitor's kiss. All the same."

DONALD: "Judas betrayed not only a man, he betrayed a people, his own people."

WILLIAM: "All the betrayals that the church leaders have committed have been like this one of Judas (Judas was also a bishop): because of not believing in the kingdom of Christ, of the poor; because of preferring domination to liberation; and finally, for money also."

OLIVIA: "And the people are then crucified."

Esperanza Guevara

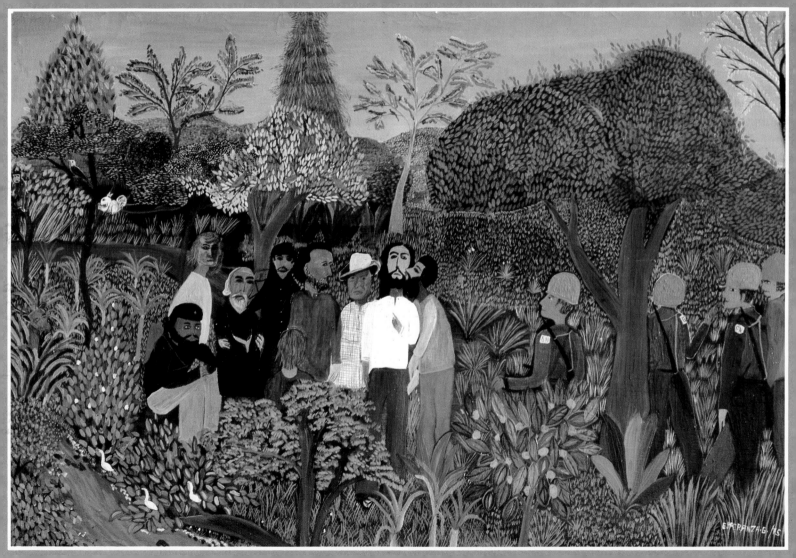

Jesus Is Seized for Questioning

Matt. 26:57–68

Those who arrested Jesus led him before Caiaphas,
the chief of the priests,
where the teachers of the law and the elders were gathered.

BOSCO: "That sounds like the Military Court that's operating in Managua."

WILLIAM: "In this case it had the same functions. They gathered at night, in an emergency session. They had to make haste, condemning Jesus right in the middle of the Passover."

FELIPE: "At that time Christ was all alone. Now there are many Christs being sentenced in many places."

ERNESTO: "They may even have accused him of leading an evil life. Earlier in the Gospel we've seen that the Pharisees spoke against him because he went around with sinners and prostitutes. So they probably poked into his private life. But it says here they had no proof. So they accuse him on account of the temple. He had just taken over the temple. They're probably referring to that in the trial. But they couldn't really accuse him of that, of driving out the merchants. He had done this by citing the Bible prophets. They couldn't accuse him of purifying the temple of those corruptions. So they accuse him of trying to destroy the temple."

FELIPE: "Those people were like many people today who give more importance to a house than to a human being. They were giving a lot of importance to that house, that temple, which is like saying this church, as though that was ruining the people. There are others who are ruining the people and killing people and they don't accuse those people of anything. Let's suppose Jesus wasn't going to destroy that house, but Jesus was opposed to the idea of giving more importance to houses than to people's bodies."

ERNESTO: "They made two accusations, the religious accusation before this court, and the political one before the court of Pilate. It was really the same one, proclaiming himself the Messiah, which for them was a religious crime and at the same time a political one, because the Messiah had to be the king. Just as against us they can make an accusation at the same time religious and political. They did it to us when the Head of Customs in Managua sent a telegram to all the customs houses in the country forbidding the importing of the first volume of our *The Gospel in Solentiname,* because it was a very harmful book that 'by means of the Gospel tries to preach communism to the people.' "

They said: "He is guilty and he must die."
Then they spat on his face and they struck him.

GLORIA: "It's tough to be a Christian, because anybody who's a Christian has to be ready for all that, those tortures. It's nice to say that I'm a Christian, but as for the rest. . . ."

Olivia Silva

As against a robber you have come out,
with swords and clubs to seize me.
Matt. 26:55

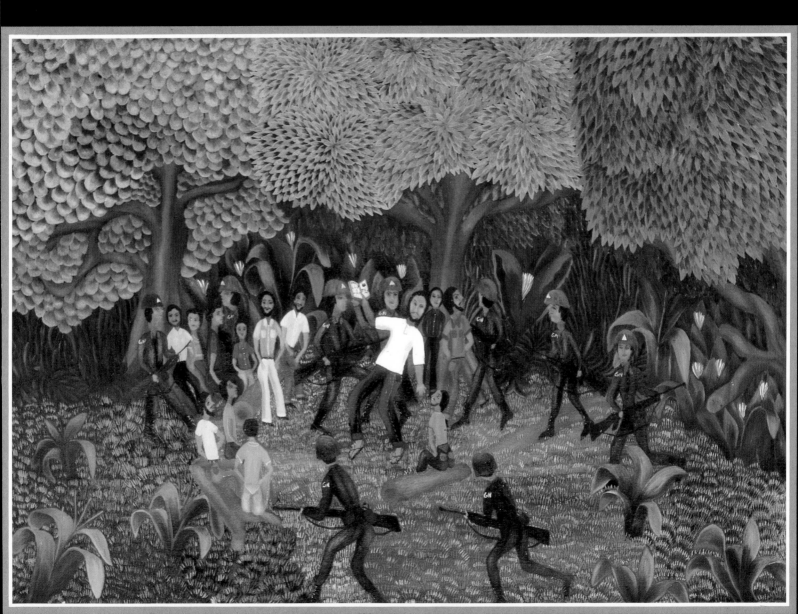

Jesus Before Pilate

John 18:28–40; 19:1–16

The Jews did not go into the palace
lest they become impure,
for then they could not eat the Passover meal.

FELIPE: "They have scruples about entering a pagan house, but they have no scruples about taking Jesus there to be condemned to death. All they worried about was eating the Passover meal without 'sin.' "

OSCAR: "It was people very conscientious about their religious duties that killed Jesus."

ERNESTO: "The religious people condemned Jesus for having declared himself the Messiah. Pilate didn't care about that; for him it had something to do with the religion of the Jews; so they have to present that to Pilate as a political crime, because he was coming to change the world. In their court, which was a religious court, they had condemned him for religious crimes because he had declared himself the Son of God. Before the civil court they accuse him of having proclaimed himself king. King as the Romans understand it, or as the Jews understand it? King as the Romans understand it he is not. King, Messiah, as the Jews understand it, one who comes to change the world, that he is."

OLIVIA: "It seems to me that when they heard 'king' all they thought of was a kingdom of injustice like their own kingdom, and he's telling them that his kingdom is a kingdom of love. But that didn't suit them either, the kingdom of love, because love is against injustice. And that's why the powerful still go on being against this kingdom of love. They always fight against this revolution of love because it doesn't suit them. For them, the kingdom of love is subversion."

RAUL: "On the contrary, Christ's mission was to bring truth to the earth. He says to Pilate: 'I am a king, and my political order is to put an end to lying and exploitation; my followers are all those who struggle for the transformation of the world.' "

Then Pilate ordered Jesus to be whipped.
On his head the soldiers placed a crown of thorns,
and they covered him with a purple mantle
and they went up to him saying:
"Long live the King of the Jews!"
And they kept hitting him in the face.

LAUREANO: "He had come to be the king of the poor and humiliated of the earth, and when they put that rag on him to make fun of him and they hit him, there he is in his true role as king of all the poor, the humiliated, the beaten, the tortured."

ALEJANDRO: "He was the king of the people oppressed by the kings. He was our king."

And so Pilate turned him over to them to be crucified.

WILLIAM: "And Pilate washes his hands."

RAUL: "And the chief priests went off to their homes to eat their Passover meal without 'sin.' "

María Altamirano

58

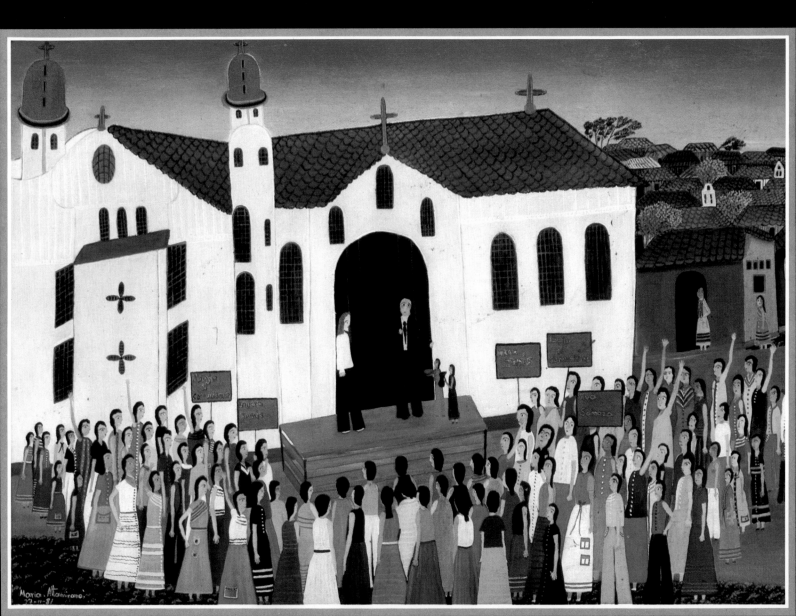

The Way of the Cross

Luke 23:26–32

Good Friday. In church, at three in the afternoon, in suffocating heat. We are in the worst of the dry season, which is called "summer" here. No breeze blows, not a leaf moves, and the lake is as still as though it were a stone. All around us all the vegetation is dry or withered. Farther off the fields appear black, charred, because they've been burned for future crops, when the rains come. In the air there's a burnt smell.

Many people were following him
and many women who were crying and shouting with sorrow.

TERESITA: "There were a lot of people who loved him. And especially the women. He was their liberator and in his passion they were faithful to him."

ERNESTO: "Those women were revolutionaries, and that's why they got involved and supported him. And among them was his mother, the most revolutionary of them all. It was she who had said during her pregnancy: 'The powerful will be toppled from their thrones and the humble will be exalted, the hungry will be filled with good things and the rich will be left without a thing.' She was a 'revolutionary' and a 'communist' before Jesus was born. Those ideas she had received from the prophets of the Bible. And those ideas Jesus sucked in with her milk. She shaped him, she influenced him, she contributed greatly to his being what he was and to his meeting the end that he did."

Turning to them Jesus said:
"Women of Jerusalem,
do not weep for me,
weep for yourselves and your children."

MARIITA: "Those women were people who understood him, that is, they understood his sacrifice. And maybe Jesus said to himself: you weep and maybe you don't know you're going to suffer the same fate and that they're going to kill you, too. Because there wasn't any justice."

ERNESTO: "Above all he is foreseeing the sufferings that the Romans were going to cause in Jerusalem. Many, many young people were going to rise up and they would be sentenced like Jesus. The Wailing Wall is still in existence, where Jews go to bewail the ruin of Jerusalem."

OSCAR: "Lots of people in Holy Week think only about the sufferings of Jesus, and they don't think about the sufferings of so many Christs, of millions of Christs that exist. And Jesus didn't want them to be wailing for him but to wail for the others that were going to suffer like him or worse than him."

LAUREANO: "Still right now there are people that are suffering for the same cause, and maybe they're suffering more than him, because at that time crucifixion was a kind of torture but you died right then and there; now they torture you but they leave you alive."

Rafael Ch.

After they had mocked him, they led him out to crucify him.

Mark 15:20

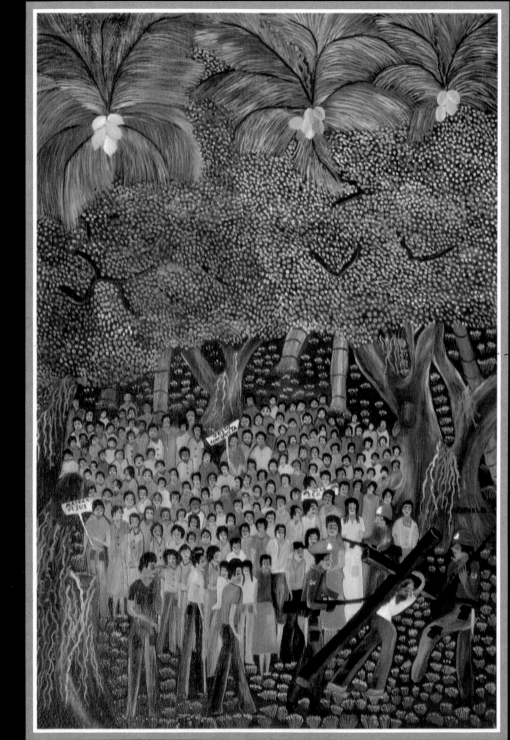

The Crucifixion

Luke 23:33–49

And when they were crucifying him,
Jesus said:
"Father, forgive them,
because they don't know what they're doing."

OSCAR:"Nowadays the same thing happens with the torturers, because these people are machines; they don't even know why they're torturing somebody. That's why Jesus says: 'Forgive them, because they don't know what they're doing.' "

LAUREANO: "That was just like now; the soldiers and the Jews didn't know what they were doing, but Pilate and the Sanhedrin did know. They knew that Jesus was against the powerful, and that he was the Messiah who was going to liberate the people. Just like today, the ones who persecute anybody who wants to make a change, they know very well why they're doing it. Somoza knows why he's doing it. The United States knows why it's doing it."

We read that one of the "criminals" asks Jesus to remember him when he begins his reign. And Jesus says to him:

"I tell you truly that today you'll be with me in Paradise."

ERNESTO: "The man talked to him about his kingdom, and Jesus talks to him about Paradise. In Genesis Paradise had been presented as something that there was at the beginning of humanity. But the intention of the biblical writer was not to present to us a past that we were to yearn for in vain (the Bible never looks backward) but to present to us a *utopia,* a future goal for humanity. The prophets speak of Paradise as something that would be in the future, and they identified it with the messianic era. And Christ says that Paradise (his kingdom) begins now, that afternoon. With his death. He died while all Jerusalem was celebrating Holy Week. So while he was dying on the Cross, in every house they were eating the ritual paschal lamb—just as David Tejada was beaten to death on Good Friday, at the hour when they were making the Stations of the Cross on the streets of Managua. And his body was then thrown into the crater of the Masaya volcano."

WILLIAM: "The Christianity that we had was very false, and every year we heard about the Passion, but we didn't understand it the way we now understand what Good Friday is. Now we're gradually understanding it and we're gradually having courage to stand up to things."

ERNESTO: "One day the whole life of the earth is going to die, like these fields that are dry. The earth will be a dead planet in space, and in it will be buried all our bones. But all that part of humanity that, like Jesus, has delivered up its life to love will be alive in the universe—in love, which is the soul, the life of the universe, like Jesus, who came out of the tomb. According to the Book of Revelation, Christ is only the first-born of a resurrected humanity."

There is a prolonged silence, broken only by the lowing of the cows in the dry fields.

Gloria Guevara

"*Father,
into your hands
I commend my spirit.*"
Luke 23:46

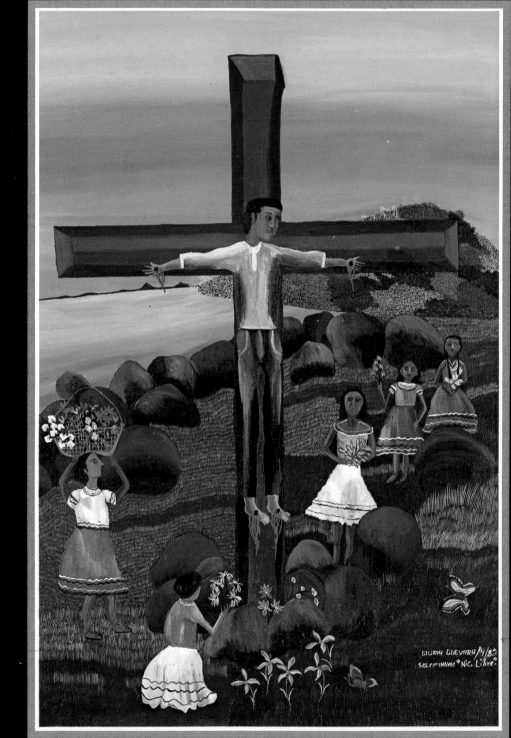

Jesus Is Laid in the Grave

John 19:38–42; Luke 23:55–56

We read aloud from the Gospels of Luke and John how Joseph of Arimathea arrived after Jesus had died. He was a member of the Sanhedrin but had not consented to what the others did when they had condemned Jesus and sent him to Pilate. In fact, Luke describes Joseph as an upright and virtuous man who lived in the hope that he would see the Kingdom of God. This man asked Pilate for the body of Jesus, and when Pilate gave his permission Joseph took the body down from the cross. He was joined by Nicodemus, a teacher of the law who had once visited Jesus at night. Then we remembered what Jesus had told Nicodemus that just as Moses lifted up the serpent to save the Israelites in the desert, so must Jesus be lifted up, so that those who believed in him would have life everlasting. And we guessed that Nicodemus was remembering all these things, too, as he and Joseph wrapped Jesus in a shroud and carried him to a garden which was also a burial place.

The women who had come with Jesus from Galilee followed Joseph and Nicodemus into the garden. The women, Luke says, took careful note of just where the grave was. Then they left to prepare spices and ointments, and on the sabbath day they rested, as Jewish law required.

OLIVIA: "I believe that if the Gospel were preached and discussed everywhere as it is in Solentiname, there'd be an end to that ridiculous Holy Week they have. Instead of those traditional ceremonies and prayers that they commemorate the death of Jesus with, everybody would go into action to see what we can do for each other, and we'd take into account the injustice that some people haven't even had enough to eat in this Holy Week. They once used to tell us that we shouldn't even take a bath on these holy days, because Jesus was under the earth. Jesus came to wake us up. He died so he could come back afterwards to act more effectively."

TERESITA: "Since everything Jesus did was good, you can never get to the end of telling all the things he did."

WILLIAM: "And keeps on doing—the great changes he made in people and in the world, and that he goes on making and will go on making through his followers."

ERNESTO: "And all that he did and said—and it's told here in the Gospel—we comment on and we can go on commenting on it for a long time. And we could say that these commentaries never end. And we believe in this Jesus because we believe in the testimony of those who knew Jesus. That's why we are here holding this book in our hands, the story that through many hands has reached us, on the shore of this lake."

Rosa Pineda

64

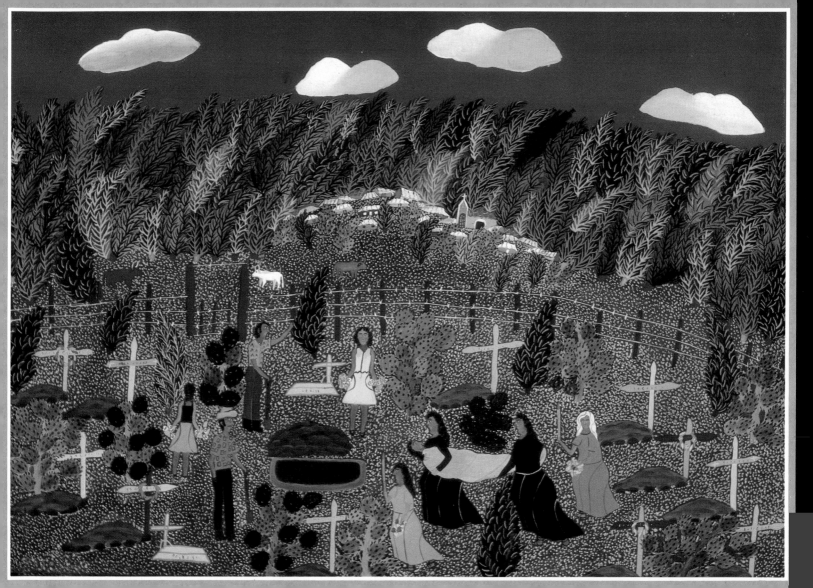

The Resurrection

Matt. 28:1–10

When Saturday ended,
at dawn of the first day of the week,
Mary Magdalene and the other Mary went to see the tomb.

Old TOMAS: "They got up early because they wanted to. And they were brave, because they weren't scared of the National Guardsmen that were on duty there."

OLIVIA: "The death of Jesus, who died for love, had filled them with that courage, the courage of love."

LAUREANO: "I don't see what courage those women had. They weren't running any risk by going there; the soldiers weren't attacking the women or doing a damned thing to them. Going to see Jesus and weeping for him there, why were they running any risk?"

WILLIAM: "It takes a certain courage, man; it's like going now to lay flowers on the grave of a guerrilla fighter."

MARIA: "They agreed to take care of Jesus' body, and when they didn't find it there they said: 'They've stolen it; they've taken it away.' Like what happens with the leaders, they kill them and they won't even give you the body."

OLIVIA: "And afterwards he appears before them and shows them he's alive."

ERNESTO: "And he goes on showing us that he's alive, us, gathered here twenty centuries later; and he's present in the midst of us."

WILLIAM: "The important thing is that he's alive wherever there's community."

Then the women went quickly from the tomb,
with fear and at the same time with much joy;
and they ran to bring the news to the disciples.

FELIX MAYORGA: "They ran to bring the news to their friends. But that news wasn't just for them but so that the news could go afterwards from mouth to mouth. After many centuries it has reached as far as us in Solentiname. And later it will be heard by people not yet born."

OLIVIA: "The news is not only about his resurrection but about ours."

ERNESTO: "That's why Olivia didn't wear mourning but wore a green dress when her daughter Olga was buried."

Olivia Silva

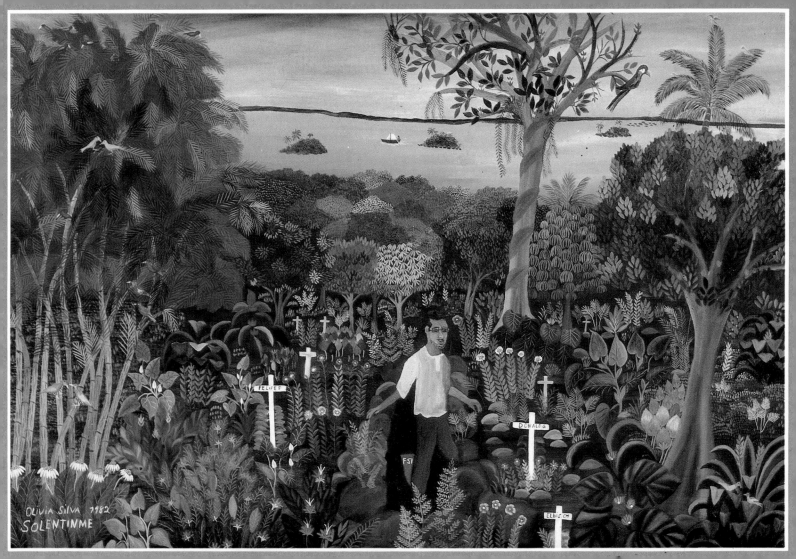

Epilogue

One day it happened that a group of boys and girls from Solentiname, because of profound convictions and after having let it mature for a long time, decided to take up arms. Why did they do it? They did it for only one reason: for their love for the kingdom of God, for the ardent desire that a just society be implanted, a real and concrete kingdom of God here on earth. When the time came, these boys and girls fought with great valor, but they also fought as Christians. That morning at San Carlos, they tried several times with a loudspeaker to reason with the guardsmen so they might not have to fire a single shot. But the guardsmen responded to their reasoning with submachine gunfire. With great regret, they also were forced to shoot.

Alejandro Guevara, one of those from my community, entered the building when in it there were no longer any but dead or wounded soldiers. He was going to set fire to it so that there would be no doubt about the success of the assault, but out of consideration for the wounded, he did not do it. Because the building was not burned, it was officially denied that it was taken. I congratulate myself that these young Christians fought without hate—above all without hate for the wounded guardsmen, poor peasants like themselves, also exploited. It is horrible that there are dead and wounded.

Some day, instead, there will be an abundance of schools, hospitals, and clinics for everyone, food adequate for everyone, art and entertainment. But most important, there will be love among all.

—From "A Letter to the People of Nicaragua,"
written by Ernesto Cardenal in December, 1977,
two months after Solentiname had been ravaged
by Somoza's National Guard.

Comments on *The Gospel in Solentiname*

"Upon reading this book, I want to do so many things—burn all my other books which at best seem like hay, soggy with mildew. I want to think of drawing together my impressions of this book and writing a theology of the word and of the word incarnate in Jesus.

"I am all set for composing a theology of preaching and of revelation. Most of all I know now *who* (not what) is the church and how to celebrate the eucharist.

"Ernesto Cardenal, priest, poet, mystic, and political activist, enables these people to release a spirit which must be God's. Father Cardenal is so good that the working people—some cannot read, others strain under revolutionist impulse, and all touch lovingly with brown leather hands—call him simply 'Ernesto,' as they converse together."

Carroll Stuhlmueller, Catholic Theological Union,
in *National Catholic Reporter*

"*The Gospel in Solentiname* looks at the story of Jesus and the problems of religion not through the eyes of a scholar but through the simple faith, doubts, and expectations of a number of poor Nicaraguans and a few educated persons who share with them the yearning for a just and peaceful world.

"The book is valuable because it gives us an insight into the practical faith of a group of poor people in Latin America who look to Jesus and Christianity to bring them freedom and liberation from economic and political oppression."

Andrew C. Varga, S.J., Fordham University, in *America*

"Whoever has not become convinced that it is little ones who capture the spirit of the gospel should find in the book *The Gospel in Solentiname* a certain discomfort. It is not a book which permits us to remain comfortable with whatever lukewarmness we bear within us.

"The simplicity and directness of interpretation with which the community of Solentiname illumines the gospel teaching cuts deep into our complacency. There were more than a few challenges issued me in reading this book.

"At Solentiname the dialogue replaces a homily during the mass. After one becomes accustomed to the format, he receives from this format a real sense of Presence. The spirit dwells where the people are aware of their littleness."

G. Paul Gunther, in *The Catholic Weekly*

"If you feel uncomfortable with such words as injustice, oppression, and exploitation, then don't read this book. On the other hand, if you are looking for a refreshing kind of gospel commentary, you will find this book exceptionally rewarding.

"With the exception of Father Cardenal, these comments are not from theologically or biblically trained minds. These are affirmations of very ordinary people who see the message of Scripture through their own eyes.

"Furthermore, these are Latin Americans who, like a vast majority of their brothers and sisters in Central and South America, feel very keenly the deprivation in which they have lived for generations. Poverty is a way of life for them.

"Therefore the reader should not be surprised to see these things reflected as the gospel narratives are considered. They clearly demonstrate the impatience of many deprived people who wish to see the promises of God fulfilled in the here-and-now rather than in the hereafter."

William E. Cox, in *World Encounter*

"Those who lead groups for Bible study will find in this book not only a possible source for group sharing, but a model for leadership. The priest is present to listen, to offer enriching background, to clarify, but never to dominate. Perhaps that is why the presence of the Spirit can be so clearly felt in these pages."
Religion Teacher's Journal

"The ability to inspire a people to be so inspired in themselves, people who in many cases cannot even read or write their own names, is a special grace. One might perhaps best call it mystical. *Muein:* to shut the eyes—as if blindness to learning and scholarship enabled one to see deeper and more clearly, to listen more attentively, to be free enough to be *educated* in the needs of a people rather than simply *instruct* them to voice only those needs which the present structures and institutions are prepared to service. In the case of Ernesto Cardenal that process involved many long and difficult years of spiritual struggle, from stripping away ambitions to an academic literary career, to detachment from social status, to a defrocking of the conventional notions of priesthood and Church.

"Ernesto's logic is that of the poet who takes it as his duty to create a myth for his people with images. He builds up painstakingly a sort of mosaic of words, feelings, experiences, and hopes, caring little for the nuances of dialectic and distinction which might give it scholarly stature. Also, as he carries on his process of self-tutoring, he shares what he finds with his community.

"And why not? If for centuries the Christian Church has tolerated among its masses of believers a pure and uninhibited devotion to transcendent ideas whose theology they could but dimly understand, why not promote the same devotion to the cause of social Revolution as well, at the same time as the slower process of critical education goes on? At least with the latter, Ernesto argues, the Gospel has a chance of sinking roots in the peasant's experience; and of becoming part of the folklore passed down from one generation to the next, instead of being shrouded and confined and laid in its grave in academia."
James W. Heisig, in *The Priest*

Of related interest . . .

Ernesto Cardenal
THE GOSPEL IN SOLENTINAME
(four volumes)

"Farmers and fishermen in a remote village in Nicaragua join their priest for dialogues on Bible verses. Here is a translation (earthy epithets intact) of the tape-recorded conversations. Highly recommended to confront the complacent with the stark realities of religious and political consciousness in the Third World." *Library Journal*

> *Vol. 1, 288pp. Paper $8.95*
> *Vol. 2, 272pp. Paper $8.95*
> *Vol. 3, 320pp. Paper $8.95*
> *Vol. 4, 288pp. Paper $8.95*

William J. O'Malley
THE VOICE OF BLOOD
Five Christian Martyrs of Our Time
(3rd Printing)

"Anyone who has seen an issue of *Amnesty International,* with its documented cases of murder, torture and harassment by repressive regimes all over the world, will recognize the background for this agonizing and powerful account of modern-day martyrs. The author, a teacher, playwright and drama director, has taken the bare facts of the murders of five Jesuits in not dissimilar situations in El Salvador, Brazil and Africa during 1976-77 and written a story of suspense, exploitation, violence and Christian resistance that rivets the attention and commands a response." *Spiritual Book News*

"Father O'Malley tells the stories of these men well, in simple but vivid terms. Together they spell out the demands that Christian discipleship continues to make in a world where the struggle for justice and freedom exacts a bitter price." *Library Journal*

195pp. Paper $7.95

Martin Lange & Reinhold Iblacker, editors
WITNESSES OF HOPE
The Persecution of Christians in Latin America
Foreword by Karl Rahner, S.J.

"The authors, a German journalist and a German religious affairs reporter, recount the oppression and violence suffered by campesinos in Paraguay, Bolivia, El Salvador, Guatemala, Ecuador, Brazil, and several other Latin-American countries. This book is important because, if understood, it offers a poignant view of the anguished but confident suffering of people who are attempting under great personal risk to live out their faith nonviolently as disciples of Christ. It helps to define the enormous overtowering concerns for those concerned about the communication of the gospel and its implications in societies living under authoritarian and militaristic regimes. The questions are excruciating, for in so many cases the church has a legacy of close association with those who perpetrate oppression and violence." *Mission Focus*

176pp. Paper $6.95

Michel Bavarel
NEW COMMUNITIES, NEW MINISTRIES
The Church Resurgent in Africa, Asia, and Latin America

This book is a journalistic account of small Christian communities in a variety of cultural and geographical settings throughout the Third World. The vitality of the young churches is dramatically portrayed as a picture of the Church as the Church must increasingly become. Through this portrayal, the challenge for the First World is eminently clear.

Christians can never be anything except "people of the universal church." Right from the start the disciples headed for the ends of the earth, and for the outermost bounds of their own selves. This is a book of living witness. It teems with the witness of the new countries, the "young Churches" that live the Gospel today in the Third World, in another culture, and in a situation of poverty as their daily lot.

128pp. Paper $5.95

Adolfo Pérez Esquivel
(Winner of the 1980 Nobel Peace Prize)
CHRIST IN A PONCHO
Witnesses to the Non-Violent Struggle in Latin America

The Nobel Prize, says Pérez Esquivel, reaches far beyond his simple person, going to all his brothers and sisters in Latin America—especially to the poorest and the most oppressed, and to the hundreds and thousands of nameless women and men who are battling for the dignity of the humble and fighting for respect for the ones they call the "marginalized"—the little people whom economic growth has passed right by: peasants robbed of their land; Indians scorned by modern society; the forgotten inhabitants of sprawling suburbs or shantytowns; Bolivian miners' wives; workers fired in São Paulo or Mexico City because they dared to strike; and the mothers of the fifteen thousand young people "missing" in Argentina today. A whole Latin America in anguish and agony. But it is a Latin America full of hope, too, and already winning victories. . .

from the Introduction

"*Christ in a Poncho* offers an invaluable introduction to non-violence in Latin America. The biographical sketch of Adolfo Pérez Esquivel, his own splendid 'ant and elephant' essay, and the very concrete case histories portray and underscore the urgency and difficulty of the nonviolent witness in that be-leaguered region 'where tomorrow struggles to be born.' Orbis has rendered a signal service in making this unique book available." *Richard A. Chartier, Fellowship*

144pp. Paper $6.95

James R. Brockman
THE WORD REMAINS
A Life of Oscar Romero

"Oscar Romero was archbishop of San Salvador for a scant time, but it was his fate to be named to the post in the years when his country awakened to the terrible injustice embedded in its society. The history of that awakening and its legacy of strug-gle is now also the history of the Salvadoran Church. It is nowhere better embodied than in the life of the martyred arch-bishop who did much to cement the alliance of the Salvadoran Church and people, restoring the Church's credibility as a force for peace and justice. James Brockman's book is fascinating as biography, particularly as it traces the development of Romero's thought during his last tumultuous years, and also as a docu-ment of the Salvadoran struggle for liberation. One is made aware of the fierce simplicity of the choices open to the nation as well as how difficult are the practical applications of those moral choices—how to work toward justice in a monstrously repressive society?" *Worldview*

256pp. Paper $12.95